THE BLACK INTERIOR

THE BLACK INTERIOR

Essays by Elizabeth Alexander

Graywolf Press

SAINT PAUL, MINNESOTA

Publication of this volume is made possible in part by a grant provided by the Minnesota State Arts Board, through an appropriation by the Minnesota State Legislature; a grant from the Wells Fargo Foundation Minnesota; and a grant from the National Endowment for the Arts. Significant support has also been provided by the Bush Foundation; Target, Marshall Field's and Mervyn's with support from the Target Foundation; the McKnight Foundation; and other generous contributions from foundations, corporations, and individuals. To these organizations and individuals we offer our heartfelt thanks.

NATIONAL
ENDOWMENT
FOR THE ARTS

MINNESOTA
STATE ARTS BOARD

Extracts from previously unpublished letters by Langston Hughes copyright © 2004 by The Estate of Langston Hughes. Published by arrangement with Harold Ober Associates Incorporated.

"kitchenette building" by Gwendolyn Brooks. Reprinted by consent of Brooks Permissions.

Poems by Michael S. Harper reprinted by permission of Michael S. Harper, copyright © 1970, 1985, 2000.

"John Coltrane: An Impartial Review," reprinted by permission of A. B. Spellman.

Published by Graywolf Press
2402 University Avenue, Suite 203
Saint Paul, Minnesota 55114
All rights reserved.

www.graywolfpress.org

Published in the United States of America
Printed in Canada

ISBN 978-1-55597-393-3

2 4 6 8 9 7 5 3

Library of Congress Control Number: 2003101174

Cover design: Julie Metz
Cover art: Elizabeth Catlett, *The Black Woman Speaks*
Licensed by VAGA, New York, NY

CONTENTS

◆

PREFACE

◆

"Today as the news from Selma and Saigon / poisons the
air like fallout," wrote the poet Robert Hayden in the
late 1960s, "I come again to see / the serene great picture
that I love." In Hayden's poem, culture consoles and the
artifact stands as a record of the human trace, a history
of the individual voice and collective living spirit. Art is
where and how we speak to each other in tongues audible
when "official" language fails. It is not where we escape
the world's ills but rather one place where we go to make
sense of them.

Each day's news brings word of human atrocity and
violation, as too many of us linger in pernicious and calci-
fied ideas of who "the other" is. In desperate times when
a citizen's raised voice seems to make no difference at all,
it feels useful to turn again to the art and popular culture
with which we speak across difference, from each to each,
to say, This is who I am, and thus, this is who we, collec-
tively, are. What might we hope for and work toward?

Culture is one way I take in the world and venture
beyond my boundaries, where I often find politics as
well as aesthetic joy so deep I experience it in my body,
where I shift and have sometimes shifted others through

my own writing and teaching. The work I do is culture work, and culture is what calls many of us into the conundrums of the public sphere. Culture and politics need not present an either/or proposition if politics is restored to its original meaning—"of the polis," the village, the community. Sometimes we encounter truths in culture not necessarily verifiable against census records or voting rolls. Sometimes in culture we find what we are hoping for before we have been able to articulate or enact it.

African American people are seen, imagined, and "known" through sociological and fantasy discourses, but the troves of our culture offer enlightening angles of vision. The historian laments caesuras in the historical record; the artist can offer deeply informed imagining that, while not empirically verifiable, offers one of the only routes we may have to imagine a past whose records have not been kept precious. The artist may, in fact, jog the historian to think in new ways about the data he or she might gather.

What unites these essays is an idea, a metaphor, of what I call "the black interior," that is, black life and creativity behind the public face of stereotype and limited imagination. The black interior is a metaphysical space beyond the black public everyday toward power and wild imagination that black people ourselves know we possess but need to be reminded of. It is a space that black people ourselves have policed at various historical moments. Tapping into this black imaginary helps us envision what we are not meant to envision: complex black selves, real and enactable black power, rampant and unfetishized black beauty. What do we learn when we pause at sites

of contradiction where black creativity complicates and resists what blackness is "supposed" to be? What in our culture speaks, sustains, and survives, post-nationalism, post-racial romance, into the unwritten black future we must imagine?

The cover image that this book is fortunate to bear is of Elizabeth Catlett's 1970 sculpture, *The Black Woman Speaks,* and it exemplifies my thoughts herein. Catlett has made potent, relevant art from the 1930s to this day, and her career has remained vital through dramatically changing times. She created this sculpture when her career was fully mature—at a complex, turbulent moment in this country's history—and like the mature Gwendolyn Brooks in 1970, Catlett's art managed to speak straightforwardly "to the people" at the same time that it evinced artistic power and mystery. The black woman's mouth and eyes in Catlett's sculpture are wide open. What is she seeing? What is she saying? What is inside? On the side of the sculpture, just behind the woman's temple, Catlett has inscribed a spiral-like symbol. The spiral is a symbol of infinity; this infiniteness of "The Black Woman's" inner life and imagination is the unyielding premise of these essays.

THE BLACK INTERIOR

TOWARD THE BLACK INTERIOR

◆

I saw in Mobile a room in which there was an
over-stuffed mohair living-room suite, an imita-
tion mahogany bed and chifferobe, a console vic-
trola. The walls were gaily papered with Sunday
supplements of the *Mobile Register*. There were
seven calendars and three wall pockets. One of
them was decorated with a lace doily. The mantel-
shelf was covered with a scarf of deep home-
made lace, looped up with a huge bow of pink
crêpe paper. Over the door was a huge lithograph
showing the Treaty of Versailles being signed
with a Waterman fountain pen. It was grotesque,
yes. But it indicated the desire for beauty. And
decorating a decoration, as in the case of the
doily on the gaudy wall pocket, did not seem out
of place to the hostess. The feeling back of such
an act is that there can never be enough of beauty,
let alone too much.

ZORA NEALE HURSTON,
"Characteristics of Negro Expression"[1]

In my mother's living room, there are shelves upon which
she has arranged many beautiful and extraordinary objects.

3

There is glassware shot through with cobalt streaks; a tiny, broken robin's egg; translucent, golden whelks; conch and limpet shells; dessert plates painstakingly painted as the peacock's splendid tail; wild branches of sun- and salt-bleached coral; sea fans dried in the course of their undulation; polished stones of all colors; and a dozen egg-shaped stones of different hues and sizes nesting in a Styrofoam egg carton. My mother calls them "the shelves," the objects perhaps "treasures." I call the six shelves together an altar where her intuitive and artful arrangement divines power: the power of beauty itself; the power of precious objects put together to add up to more than their mere sum; the power of the stories behind each object; the power of a family and those who have blessed them and their home. Those shelves may be the presentation piece of the living room and our family's home, but my mother alone arranged them; they speak of her aesthetic and her eye—an aesthetic made collective as it speaks for my family to announce that this is our home, sacred and beautiful. The living room is where she reveals who we are.

Ntozake Shange writes: "As black people we exist metaphorically and literally as the underside, the underclass. We are the unconscious of the entire Western world. If this is in fact true, then where do we go? Where are our dreams? Where is our pain? Where do we heal?"[2] If black people are the subconscious of the Western mind, where is "the black subconscious," both individually and collectively articulated? My interest is not in psychotherapeutic culture and African American literature—though what a fascinating topic that is—but rather the marker such language offers for identifying complex and often

unexplored interiority beyond the face of the social self. If black people in the mainstream imaginary exist as fixed properties deemed "real," what is possible in the space we might call surreal? Shange powerfully suggests that the contagion of racism seeps into the intimate realms of the subconscious and affects how black people ourselves see and imagine who we are. Indeed, by writing a book of dream poems I learned that race, gender, class, sexuality—our social identities—exist and have been "always already" constructed in the dream space, even when they are constructed outside of a racist impetus. I imagined that in dream space I was a somehow "neutral" self, but I found no such neutrality there. Yet social identity, in unfettered dream space, need not be seen as a constraint but rather as a way of imagining the racial self unfettered, racialized but not delimited. What I am calling dream space is to my mind the great hopeful space of African American creativity. Imagining a racial future in the black interior that we are constrained to imagine, outside of the parameters of how we are seen in this culture, is the zone where I am interested in African American creativity. "The black interior" is not an inscrutable zone, nor colonial fantasy. Rather, I see it as inner space in which black artists have found selves that go far, far beyond the limited expectations and definitions of what black is, isn't, or should be.

As black people we have been bound by mainstream constructions of our "real," and we have bound ourselves with expectations that we counter those false realities. Problem Number One: The black body has been misrepresented, absented, distorted, rendered invisible, exaggerated, made

monstrous in the Western visual imagination and in the world of art. The visual art world hegemony is very, very white. Black people have always made art and always imagined and understood ourselves to be other than monstrous stereotype. Therefore, the "real" black figure is a very different thing from the imagined one, and versions of what that "realness" looks like will frequently contradict each other. How do we understand "reality" when official narratives deny what our bodies know? Rape law before Emancipation classified black women as essentially "un-rape-able" because black female bodies were usually somebody's property. Indeed, some men who raped black women were prosecuted as trespassers on another man's property. And some historians assert that not until the 1960s was a white man convicted of raping a black woman in the American South.[3] How does the body that has been raped assimilate that knowledge into a coherent narrative of self against the concomitant denial of what it knows?

Problem Number Two: The Negro is in vogue, and there is much clamor for his or her story. But how do we recognize if that story is "real," if it is "authentic"? Gwendolyn Brooks, in her heartbreaking poem, "The Life of Lincoln West," writes of a little black boy about whom a white man says:

> THERE! That's the kind I've been wanting
> to show you! One of the best
> examples of the specie. Not like
> those diluted Negroes you see so much of on
> the streets these days, but the

real thing.
Black, ugly, and odd. You
can see the savagery. The blunt
blankness. That is the real
thing.[4]

"The blunt blankness" is "the real thing"; all other "Negroes" are "diluted" and therefore not "real" enough. The white speaker looks at a child and can only see "blunt blankness," which is what he reports to be real. And the black child is left to assimilate his inner sense of self with the knowledge that he has been, and will continue to be, so assessed by others.

We are too often prisoners of the real, trapped in fantasies of "Negro authenticity" that dictate the only way we truly exist for a mainstream audience is in their fantasies of our authentic-ness. Escaping from the compelling power of the imagery around us is no small feat. Where is our abstract space, our space of the real/not-real, our own unconscious? Is "real" the opposite of "abstract"? Of course not. But to take painting as an example, if African American work is in some way figurative (has bodies in it), it can pose a discomfiting challenge to the art world and to the black artist as well. Regardless of the artist's intent, he or she is painting against a history of deformation and annihilation of the black body and is thus challenged with resisting or redirecting the current (though ancient) vogue for a stereotypical black realism. Many black viewers are looking for "positive imagery," and while we often need those images, the power of the wish places

constraints on what a black artist might feel free to envision and find in that subconscious space.

"Real" has found its place in black vernacular. Queer real, diva real, affirmation. "You make me feel mighty real," the late, great Sylvester sang; and realness was the pinnacle of fulfilled existence, the most desirable state. Realness is also the ultimate litmus test that progress-minded black people place on one another, with often narrow definitions of how that realness might be embodied or enacted, or what it actually means to "keep it real." "Got to be Real," Cheryl Lynn wails, and her "Real real real real real" repeats and careens and keens and becomes its own thing, the anthem of a generation, a call to arms, a call to each other and our newfound communal freedom-in-racial-and-sexual realness. The verb "to be" becomes a new verb, "to be-real." In that disco-era hit, "realness" as sound has become abstract and therefore leaves room for invention and redefinition, a realness that goes so far as to be emptied of meaning and reclaimed as possibility.

The 2002 show *Black Romantic* at the Studio Museum in Harlem was subtitled, *The Figurative Impulse in Contemporary African American Art.* The show underscored a wide-ranging urge among diverse African Americans to see ourselves represented in art and to see fresh takes on that old sawhorse, "positive imagery." So many of these paintings feature uplifted heads, eyes, and chins, as though the black bodies attached to them are ever-striving, ever-hopeful, ever-expectant, ever-questing for the hope of a better racial tomorrow. As Valerie Cassel writes in the exhibition catalogue, "Black Romanticism is still about the insistence of presence. The visual language

used to render the images found within this exhibition is a vernacular that is easily consumed, yet rich in an art historical and collective history (albeit sometimes fictionalized). And, while sometimes pedantic, these images create a pragmatic space in which the black body is not only visible, but also safe."[5]

In the spaces we designate and create, the self is made visible in the spaces we occupy, literal "black interiors," the inside of homes that black people live in. Are the living rooms of those homes, the spaces most consciously arranged and presented, representative of not only living space but of one's self, one's aesthetic self? Issues of public and private display are preeminent for African Americans. The living room is a presentational space but at the same time, a private one. Within a home it is also a "not" space: not the bedroom, or the bathroom, or the kitchen, which is to say, the space where you do the things that are not done in those other spaces. Even in, let us say, one of the compact kitchenette studio apartments of Gwendolyn Brooks's poems, activity is nonetheless designated in certain spaces. If the "living room" is not bound by walls, I am talking about the space where we don't do what we do in those other spaces, and the space of a home that is imagined as presentational. It is therefore a theatrical space, and, in a still visual realm, a space for tableau or *retablo,* with its connotations of the sacred. The living room is where we see black imagination made visual, a private space that inevitably reverberates against the garish public images usually out of our control. What does how we arrange interior space say about how we live? And what does that say about who we are? Is there a

particular power of the visual to make possible or imaginable that which is not the present reality?

In 1937, Benjamin Brawley, then professor of English at Howard University, wrote an extraordinary book called *The Negro Genius* in which he reviewed black cultural achievement through 1936. He wrote: "The temperament of the American Negro is primarily lyrical, imaginative, subjective; and his genius has most frequently sought expression in some one of the arts."[6] His argument would not stand up under the scrutiny of today's post-essentialism, or even the nationalism of a generation ago that eschewed notions of Negro naïveté or absence from the regions of the empirically intellectual, but this was nonetheless an important observation in its time for thinking about black genius. Brawley wrote:

> If one has taken note of the homes of Negro
> peasants in the South, he must have observed
> that the instinct for beauty insists upon an outlet.
> If no better picture is available, there will be a
> flaming advertisement on the walls. Few homes
> have not at least a rosebush in the garden or a
> geranium on the windowsill. . . . In some of our
> communities Negroes are often known to "get
> happy" in church. It is never a sermon on the
> theory of the Atonement that awakens such
> ecstasy. Instead, this accompanies a vivid descrip-
> tion of the beauties of heaven—the walls of jasper,
> the angels with palms in their hands, and, best of
> all, the feast of milk and honey. It is the sensu-
> ous appeal that is most effective. The untutored

Negro is thrilled not so much by the moral as by
the artistic and pictorial elements of religion.

The will to beauty, the will to fantasy, the will to wish, the
power of wish, wish translated to action, all are identified
and enacted through the power of the visual. The living
room is the space where this "takes place."

Contemporary artist Adia Millett makes child-sized
dollhouses with very grown-up interiors that must be
viewed by peeping in the doll-sized windows: Doritos,
Crisco oil, and Pasta-Roni on the counter of the kitch-
enette, a plastic-covered couch, a shopping cart of mis-
cellany, all the markers of specific homes and how their
imaginary residents live, eat, sleep, and recreate, riffing
on the fantasia of the dollhouse and the mass-marketed
Barbie Dream House. Notably figureless, Millett's doll-
houses make the act of looking inside explicit even as
they control how much a spectator can see. You have
to walk up to the dollhouse and approach it on its own
terms, stoop and squint into the windows to take in de-
tail after detail. Her work flips the script on questions of
display. When we are not "public," with all that the word
connotes for black people then how do we live and who
are we? And how does this visual work make the move
from public to private explicit?

Romare Bearden's totemic series, "The Block," is a key
work for thinking about the public display of African
American private life. Bearden's 1971 collage, *The Block I,*
is a long horizontal rectangle, setting up a sense of the
forward movement of narrative from the start. Although

Palmer Hayden and Archibald Motley could be called the artistic progenitors of the African American street scene, Bearden moved behind the façade of the block inside his subjects' homes and lives. For the buildings he has used plain brown paper, bricks he has painted himself, and what looks to be brick-patterned Contac paper, reminiscent of the wood-grain paper used by Picasso in his first collages. This block is bookended with a liquor store and a barbershop anchored in the center by the Sunrise Baptist Church. Bearden has painted the illusion of "cuts" into the buildings not solely in the regular spaces where windows would be but rather at random spots, as though cutting through the brick itself. In this way the viewer feels less like a Peeping Tom and more like a privileged observer placed squarely in the middle of life lived. The irregularity of the cuts adds to the element of spontaneity and therefore "authenticity." Yet Bearden also makes a viewer aware of this status of invasion, of looking in without having asked permission. Additionally, because we do not see into every room, the viewer is aware that choices have been made as to what to reveal and what to keep private. The grave boy looking out might be asking, Who are you? as the viewer asks the same question. The angels burst from the brick at the top of the work, making us aware of the constructed frame that defines and sometimes constricts a community as well as the spiritual necessity of imagining movement beyond those boundaries.

"The Block" speaks brilliantly to issues of secrets, privacy, life lived on the stoop, and the need to show and say more than stereotypes of Negro pathology. It calls to mind the act of coming into someone's home, invited or

not; the collage makes you want desperately to see every-
thing inside. Think of the extent to which black life is
so consciously about presentation. Whether that image
presented is church lady or thug, the sense that we are
always being evaluated has everything to do with how we
comport ourselves. Certainly this pull to respectability
has been a tension at the center of our literature with
different stakes: Frederick Douglass criticizing Henry
Box Brown for giving up too many details of how he
escaped; Linda Brent whispering and pulling the veil
over details of her sexual violation so the white ladies to
whom she pleads her case could continue to breathe and
hear her; Langston Hughes's early black critics urging
him to keep a clerical job doing tedious data input for
Carter G. Woodson rather than wait tables because office
work was more respectable for an up-and-coming poet
and then criticizing his poems for drawing too heavily on
the frankness of the blues tradition, et cetera.

When thinking about paintings of living rooms by
black artists as representative interior spaces, I interpret
"living room" broadly, from the doilied table spaces of
Horace Pippin's *The Thankful Poor* to the basement space
of Palmer Hayden's *The Janitor Who Paints,* where the
janitor's creative, intimate self is shown as he paints a
portrait of a woman and her baby. The surprise of the
painting is what it reveals, both about this space that
might not have been thought of as anything other than a
basement hole but is instead a light-filled site of creation,
and about the janitor himself, known by the job he does
cleaning up after other people and here illuminating
another part of his inner self. Living rooms are specific

and revealing about class, as you see especially in the hard-working middle-class living rooms where the few decorative objects are lovingly tended, where the room is a set piece, clearly used for occasion, and the occasion of the painting is a very particular remembering. These are on display in Kerry James Marshall's paintings of living rooms with the glittered and winged dreams above revealing the interior wishes and tended hopes of the inhabitants who so decorously receive company.

In the Beauford Delaney painting, *Beauford Delaney's Loft*, bohemians hang out downtown in the not-Harlem, where realistic space and scale shift seamlessly. Real human figures become nudes who could be artist's models or works of art themselves. The real world and the made world—made and imagined as art—flow into each other in a realistic narrative of multihued groups of bohemians in a loft space. The open and high space of the loft distinguishes that New York domicile from the Harlem tenement. The surrealist moments where Delaney interrupts the realist logic of the painting allow us to experience the challenges to convention that is one of the raisons d'être of bohemian living.

More recently, in Pat Ward Williams's installation entitled *Move?*, a lamp, easy chair, and television mark the space as a living room. But the literal writing on the walls of the installation, the rage on the walls, is the inhabitant's political unconscious made visible. The unguarded moments in paintings or poems where the aesthetic conventions break up or are destroyed, is, I think, the equivalent of subconscious revelation.

Gwendolyn Brooks's exquisite, terse early poems of the mid-1940s portray the interior living spaces of the "kitch-enette apartments" of the black metropolis of Chicago's South Side and showcase the brilliant moves of a poet whose work in words evidences a keen understanding of the power of the visual, and the possibility of modernist interior representations to transcend the often-stereotypical portrayals of African Americans in public spaces. Brooks is a painterly poet of superb power of visual invocation whose work is in conversation with the above-mentioned painters of urban street scenes. In Brooks's artistic coming-of-age years in Chicago, fellow black artists, both visual and literary, on the South Side included Eldizier Cortor, Gordon Parks, Katherine Dunham, Charles White, Charles Sebree, Margaret Danner, and Margaret Burroughs, among many others.

Brooks's work seems activated by something at first visual and unguarded, outside of the tangle of verbal representations of the people she wrote about. She is queen of the poetic tableau, and in her work we see the interplay between black life in public—usually in the specified space of the South Side of Chicago in the 1940s, full of migrants like her DeWitt Williams who was "born in Alabama, bred in Illinois, nothing but a plain black boy"—and in startlingly intimate interior life.

Imagine a black Chicago that is finding itself the subject of the scrutiny of social science, from black social scientists St. Clair Drake and Horace Cayton, with their landmark 1945 study *Black Metropolis*, and from many other white observers. Some strove to understand

Bronzeville and its residents in their fulsome complexity, and others succumbed to the stereotypical imaginings that were the order of that day and this one with regard to black people in urban centers and the way they live. Black Chicago was understanding itself as a people *seen;* through the poet's eye, Brooks was able to get beyond the limitation of that stereotypical spectating.

The sonnet is a "little room," and Brooks reveals the equivalent of painted tableaux in her sonnets. With "kitchenette building," the poem that opens her first book, *A Street in Bronzeville,* the title names the general space, "kitchenette building," and one can imagine she is daring her readers to conjure up what they know or think they know about those specific structures and their inhabitants. But as Romare Bearden moves us from the street and building fronts of his various "The Block"s to inside those individual houses, Brooks, too, gives us a poem that is a square window or doorway, a look suddenly in, and then deeply in, beyond "garbage and fried potatoes ripening in the hall" to the "white and violet" of dreams. In her epic "Annie Allen," Brooks writes that the protagonist is led "to a lowly room / Which she makes a chapel of." She understands that any space can be sanctified, that space is what we have, and that if, as a poet, she makes space visible, manifest, then she is getting us closer to the inner lives of her poetic characters who tell us so much about black people in a very specific place and time.

Brooks is highly specific about interior space in "The Sundays of Satin-Legs Smith," for example, where she takes us into the closet of an eminent fop:

Let us proceed. Let us inspect, together
With his meticulous and serious love,
The innards of this closet. Which is a vault
Whose glory is not diamonds, not pearls,
Not silver plate with just enough dull shine.
But wonder-suits in yellow and in wine,
Sarcastic green and zebra-striped cobalt.[7]

The description goes on, and then the section concludes, "People are so in need, in need of help. / People want so much that they do not know." That portrait of an unlikely space, the closet, is a window into the subconscious life of Satin-Legs Smith. Indeed, in the stanza break after the description of the closet, Brooks tells us what she wants us to glean from the voyage in: "People want so much that they do not know." Yet she does not say, "He wants so much," because it is more than Satin-Legs that this closet has revealed to us. The closet also represents the "wants" and "needs" of the women who turn to him, "receptive," as the poem concludes, "and absolute."

Brooks's poem, "of DeWitt Williams on his way to Lincoln Cemetery,"[8] gives a sense of her acute awareness of the Afro-Modernist spaces of Bronzeville. Here DeWitt Williams, a "plain black boy," migrant from the Deep South to the Windy City, dies young, and we follow his funeral procession down the specific streets of the South Side. The title "of DeWitt Williams," suggests a Brooksian irony: this "plain black boy" nonetheless is accorded the classically heroic pageant of a death procession and also accorded the formal title, "of." The

Chicago singer Oscar Brown Jr. sings the poem as "Elegy," which unleashes a still-deeper understanding of the Afro-Modern aesthetics in the poem. "Nothing but a plain black boy" is the refrain that sticks. The poem alludes to the spiritual "Swing Low Sweet Chariot," but as Brown sings it, he invokes no tonal remnant of the original. Perhaps there is no heaven for DeWitt Williams. The repetition of "sweet" in the line "sweet sweet chariot" eliminates the full match of the spiritual reference and emphasizes instead the sweet life DeWitt, and so many like him, loved and that took him down: sweet women, sweet wine, "liquid joy."

Brooks is getting at something more than mere irony in her last line, "nothing but a plain black boy." Nothing/but. Unbestowed and yet. You can hear the blues behind it, the deepest of blues. DeWitt Williams is "born in Alabama, bred in Illinois," and Brown gives us a space, the musical blues space, for two beats after "Alabama" and "Illinois." DeWitt is both sociological and specific, one of the multitudes who made the epic journey from the South to the South Side. The poem embodies and understands the blues beneath, and that seems to be quintessentially Afro-Modern, a fusion that brings together orderly, intricate European literary form, the blues's attempt to narrate the displaced collective in a single voice (when I sing I, they hear We), and the blues for what needs some blues sung.

As Brooks's characters move through spaces marked "black," "urban," and "public," she gives us intimate details of what might be behind the millions of faces that have stared back at viewers for over fifty years. As painting

makes the invisible literal, it can challenge African American writing to see what's underneath and inside the façades we have willingly and unwillingly worn. To SEE, to lay eyes on these "black interiors," is at first startling. Then it is amazing.

THE BLACK POET AS CANON-MAKER:
LANGSTON HUGHES AND THE ROAD
TO *NEW NEGRO POETS: USA*

●

We all have "our" Langstons, the Langstons usually first encountered in childhood through poetry. The work of Langston Hughes has for several generations of readers helped form a sense of an American poetics and the possibilities of African American literature. Especially for many young black readers of more than one generation, Hughes's work presents a "race-pride" moment par excellence. He is "our" poet laureate, our "Shakespeare in Harlem," our Negro man of letters who made his living by the word and who articulated racial issues and strivings through a lens of true love for black people.

In addition to being the best-known, most-read, and most frequently taught African American and, in many cases, American poet, Langston Hughes is also the rare poet for whom one could easily conjure a picture. Think of those lovely early studio portraits, or any number of later images: the photograph with a cigarette dangling from his mouth; at the typewriter from the cover of *Selected Poems*; or the famous photo of the Negro busboy poet, newly "discovered" by Vachel Lindsay; or the picture of

him in profile and quietly joyful on a Senegalese beach at the 1966 World African Arts Conference in Dakar. We even call him "Langston," as though something in that face and those poems has invited us to do so.

Of all of the genres that he wrote in, it is foremost as a poet that we remember Hughes. This is not because he was a better or more prolific poet than he was, say, a playwright, or that he didn't accomplish as much in the Jess B. Simple stories. Certainly by 1926, for example, when he published the influential essay "The Negro Artist and the Racial Mountain," he was making a name for himself in other forms.

But the face of the poet is the face that stuck, and Hughes himself held that identity dear. In the introduction to *Poems from Black Africa*, he wrote:

> Traditionally, poets are lyric historians. From the days of the bards and troubadours, the songs of the poets have been not only songs, but often *records* of the most moving events, the deepest thoughts and most profound emotional currents of their times. To understand Africa today, it is wise to listen to what its poets say—those who put their songs down on paper as well as those who only speak or sing them.[9]

Hughes saw poetry as a representative genre of a people, and he touted its actual power. In 1965, toward the end of his life as that new era in black politics and culture bloomed and flamed, he wrote an introduction for a children's poetry booklet put out by the Student Non-Violent

Coordinating Committee (SNCC). This little *ars poetica* articulated what he believed poetry could be:

> Poetry possesses the power of worriation. Poetry can both delight and disturb. It can interest folks. It can upset folks. Poetry can convey both pleasure and pain. And poetry can make people think. If poetry makes people think, it might make them think constructive thoughts, even thoughts about how to change themselves, their town and their state for the better. Some poems, like many of the great verses in the Bible, can make people think about changing all mankind, even the whole world. Poems, like prayers, possess power.[10]

By the second half of his career, Hughes was indisputably the poet laureate of African American letters. He edited numerous anthologies in different genres. In 1949 he and his great friend, Arna Bontemps, published *The Poetry of the Negro 1746–1949,* which they then revised at the end of Hughes's life. In 1956 he published *A Pictorial History of the Negro in America,* with Milton Melzer, and in 1958, *Famous Negro Heroes of America.* The legendary African magazine *Drum,* which was published out of Johannesburg, asked him to judge their short-story contest in 1954, which began a period of deep involvement with African literature and its dissemination. In 1960 he edited *African Treasury: Articles, Essays, Stories, Poems by Black Africans,* and in 1963, *Poems from Black Africa, Ethiopia, and Other Countries.* Perhaps his best-known anthology was the 1967 publication, *The Best Short Stories by Negro Writers: An Anthology from 1899 to the Present.*

Little has been written about Langston Hughes the anthologizer, his role as a shaper of African American culture as well as a maker of it. His lifelong encouragement of younger writers is well known. But more ambitiously, his supporting impulse also represents a move to shape American literature by making the work of black writers available, and to shape African American poetry by putting forth a canon that would articulate a literature that grew and developed dramatically over the course of Hughes's life. Hughes-as-anthologizer demonstrates his participation in the making of the context in which his own work would be read and placed as well as his responsibility to his literary community. And his edited collection *New Negro Poets: USA,* which was published in 1964 after a long and noteworthy incubation, allows us to think about African American canon formation at the beginning of a decade of dramatic change.

What follows is the story of *New Negro Poets (NNP),* assembled by researching the extensive Hughes correspondence in the Beinecke Library at Yale University. Hughes died in 1967; *NNP* was his last solo take on the African American literary scene and a case study of how even the clearest cultural vision can become distorted on its way to public availability. The final book is never what it starts out to be, and the case of *NNP* speaks to the times, to white visions of black poetry, and to the making of a cultural anthology by a black poet.[11]

Anthologies require a tremendous amount of work of a certain kind, and to succeed they must implicitly tell a story. The act of consolidating and then distilling invites aesthetic and political choices at every turn, the kinds of

choices that subsequently come to appear inevitable when we read the anthology and the editorial hand is made invisible. In his essay "A History of American Poetry Anthologies," Alan C. Golding discusses Elihu Hubbard Smith's *American Poems, Selected and Original,* which was published in 1793 and represented the first anthology of American poetry. Golding writes:

> Smith's Federalism underlies what he saw as the use of his anthology: to build America's sense of identity by gathering an independent national literature to match and strengthen the country's newly achieved political independence. This particular political identity which Smith wanted that literature to embody is not what actually evolved, of course. Nevertheless, his and other early American poetry anthologies . . . did share this common goal. The term "American literature," rarely used before the 1780s, became commonplace after the 1783 Treaty of Paris. Magazines opened their pages to a flood of American writing, as their editors set out crusading pleas for the creation of a "national" literature. . . . [In the nineteenth century] the country still felt an urgent need to assert that it had an indigenous poetry recognizably different from English poetry.[12]

This analysis can be extrapolated to African American anthologies, particularly poetry collections. In his 1921 introduction to *The Book of American Negro Poetry,* James Weldon Johnson states plainly:

A people may become great by many means, but
there is only one measure by which its greatness
is recognized and acknowledged. The final mea-
sure of the greatness of all peoples is the amount
and standard of the literature and art they have
produced. The world does not know that a people
is great until that people produces great litera-
ture and art. No people that has produced great
literature and art has ever been looked upon by
the world as distinctly inferior.[13]

In the African American context, "the tradition," as such,
was still in its youth. Johnson's 1921 offering appeared just
forty years before Hughes so enthusiastically embarked
on *NNP*.

Not all poets choose to choose, which is to say, many
poets have no interest at all in the specific work and re-
sponsibility of putting together an anthology. Mollifying
the tender feeling of fellow Negro poets is a difficult busi-
ness. The Chicago and Detroit poet Margaret Danner,
for example, with whom Hughes corresponded from
1944 until his death, wrote to Hughes on 22 April 1960,
concerned about poems she hoped would be included in
New Negro Poets. In all capital letters, her missive reads,
"NOT TO BE INCLUDED IN YOUR ANTHOLOGY
WOULD HURT ME VERY MUCH." After her place
in the anthology has been assured, she sends a tele-
gram: "I'm so happy that you like me sweet and fat love
Margaret." (3 March 1963) When the book comes out, she
writes, "I am very proud to be included. [But] I wish they
had chosen some of my later work." (4 May 1964) Two

years later, when Hughes and Bontemps are revising their
1949 black poetry anthology she writes: "Please publish
new poems and please correct my birthplace," which was
listed as Kentucky in *New Negro Poets*. "I was born in
Chicago, Illinois. I have documents to prove this if others
need them. I am sure you don't." (19 October 1966)

Amiri Baraka, then Leroi Jones, also corresponds with
Hughes about his selections in *New Negro Poets*.

> Got word from Indiana a couple days ago that
> you are using poems of mine in yr ant'y. I'm
> very happy you are, and that the thing is finally
> going to come out. But one thing, how come you
> using those old poems? I've got thousands of
> poems, &c. but I suppose you're supposed to use
> what you want. But another thing strikes me as
> really curious. Why use only that small part of
> the Lanie Poo poem?? I'd much rather you used
> another poem, rather than cut that away like that.
> Is the other material objectionable because of the
> language? Please let me hear from you, maybe
> I can send you a substitute poem, or a couple of
> substitutes?? (27 October 1963)

Hughes has George Bass write a diplomatic reply to say
that the anthology has been three years in the making, and
that it is being directed "at the education market—high
schools and colleges. This prevents the use of any 'profane
and/or obscene' words . . . that is, words so defined by the
public's mind . . . the folk who buy the books." Bass also
tells Jones that the type has already been set (29 October

1963). These negotiations are part of the territory of anthology editing, and not everyone is up to the particular challenge.

The road to *NNP* begins with Hughes's editing of the Winter 1950 issue of the poetry quarterly *Voices* as a "Negro poets issue." Inclusion of more established poets, such as Waring Cuney, Melvin Tolson, Jessie Fauset, Gwendolyn Brooks, Robert Hayden, and Georgia Douglas Johnson, would not fit under the umbrella of "New Negro" a decade later. By 1960 there was a clear sense of an old guard as well as a vanguard in African American poetry. The work was abundant and in flux, and it was high time for a "second generation" of black poetry anthologies that would not include foremothers and forefathers, such as Jupiter Hammon, Phillis Wheatley, and Paul Laurence Dunbar. Even Hughes's own generation was attaining elder status, so a new black poetry would catch hold of a nascent explosion. As Rosey Pool, the Dutch Holocaust survivor and editor of the 1962 British-published anthology *Beyond the Blues,* wrote of those years, "There were black poets everywhere—an avalanche of creative power. It was like *living* a huge volume of BLACK AND UNKNOWN BARDS."[14]

In the early 1960s most American poetry anthologies were still segregated. Walter Lowenfels's *Poets of Today: A New American Anthology* featured an introductory poem by Langston Hughes. In Lowenfels's introduction he wrote:

> While there are now in print two recent anthologies of Negro poets, most general anthologies of

American poetry exclude Negroes. In a review of what I called 15 years ago "the Oxford Book of (White) American Verse," I drew attention to segregation in poetry. Research in this field shows no improvement since then. Apparently other editors do not consider the kind of poems by the 20 Negroes I have included to be poetry. My choice has been determined not by color but by what I respond to when "I hear the voice of America singing."[15]

The time was right for anthologies to perform the corrective function of making black poetry more widely available.

Hughes begins a correspondence with Bernard P. Perry, director of Indiana University Press, in 1953 when Perry asks Hughes to evaluate a manuscript of "modern negro poetry" compiled by a Miriam G. Koshland. (29 April 1953) Hughes finds it to be "very haphazardly put together," though he thinks that "the project itself is a worthy one." (16 September 1953) Hughes translates Federico García Lorca and Gabriela Mistral for the press and proposes translations of Léopold Sédar Senghor. He also puts together a collection of African short stories. Hughes was both a writer on the forefront of an international writers' scene, as well as an editor mindful of the way that literature should be collected, arranged, and made available to the public.

In the first month of 1960, Hughes writes to Perry with "an idea for the Indiana University Press: an anthology of NEW NEGRO POETS which I could compile

and edit for you. There are perhaps 10–12 quite good ones, some young, others in their thirties but just hitting their stride. . . ." He singles out Ted Joans, Leroi Jones, Margaret Danner, and Paul Vesey as the finest; wants to include "Conrad Kent Rivers, still in college at Wilberforce"; and wishes to find out if Mason Jordan Mason "is <u>really</u> Negro or not." (22 January 1960) Hughes will argue to Perry that "[t]here has been no collection of Negro poets published in the last ten years," and notes that his 1949 Bontemps anthology is still in print and selling well. (23 March 1960) Bontemps's book was a historical collection; Hughes proposes a look at the up-and-comers. Perry replies enthusiastically in just a few days: "You bet we would be interested in the anthology idea." (28 January 1960)

But when Hughes sends a preliminary manuscript, Perry is decidedly underwhelmed. Of the sixty poems submitted, Perry selects but a third and writes, "we are inclined to agree with the following comment by one of the readers . . . 'the collection as it stands seems full of worthless material, but it does contain promise and achievement.'" One reader's report states that "definitely the good stuff has little that is specifically 'negro' about it, it is not the 'naive Dichtung' we have been accustomed to expect from our colored brethren." (12 July 1960) Hughes does not contest these assessments but rather proceeds to prune and gather anew according to what he thinks Perry wants. He writes to Danner with pragmatic resignation that the press wants "a dozen of the more 'avante guarde' poets like the current beatnik crop—which they feel represents the trend nowadays—as I guess it does. Loud

and angry race cries such as you and I are accustomed to give are not at the moment 'comme il faut' or 'à la mode' as a poetic style. (But don't worry, I expect they will be again in due time!)" (7 October 1960) When he writes to Perry on that same day as the Danner letter, he does not argue with the editor's suggestions but rather submits an anthology he hopes the press will accept.

Months pass without a word from Perry or from anyone at the press. In March of 1961 Hughes writes, "WHAT, in the name of the Muses—is happening to NEW NEGRO POETS?????? LeRoi Jones is getting more famous by the minute; and Gloria Oden's on her way, too. And I've more manuscripts from a half dozen more poets." (21 March 1961) Perry's reply, almost a month later: "Part of the reason for the delay is that there are so many amateur poems and there does need to be editing. . . . I particularly liked the poem by Ted Joans entitled 'The Sermon' but as with most of the poems, they have been slapped out and apparently not worked over." (17 April 1961) But Perry remains enthusiastic about the black African poetry anthology. Hughes replies immediately with a question that resounds beyond the situation at hand: "WHAT'S HAPPENING to the poor NEW American NEGRO poets? Yea or Nay?" And each question is followed by over thirty question marks. (19 April 1961)

Perry wants to put the African anthology first, and Hughes remains behind that project: "Certainly, it will be the first anthology (to my knowledge) of African poetry in English in the Western World by indigenous (native) writers, most of whom have not been published in any

form in the USA." (5 June 1962) It is the age of optimism in Africa as colonial regimes are falling, and Hughes publishes his forward-looking poem, "Africa."

But he continues to press for the African Americans, tinkering, substituting, and adding up-to-the-moment inclusions such as "the current winner of the Urban League—Reader's Digest sponsored contest." (27 May 1961) Eventually Perry comes up with a "solution" that would allow him to publish the anthology: "One of our editors here thinks that this work has '—a kind of metrical sociology of the negro heart.' This might be an approach which would permit us to use many of the poets and poems which are unprofessional in form and execution, but moving nevertheless." (5 June 1961) And indeed, that phrase "a kind of metrical sociology of the negro heart," did appear on the dust jacket of *New Negro Poets*, credited to Professor Robert Gross, an advance apology for the "quality" of what was to come in the book.

Hughes tinkers on. In February 1963 he paves the way for Perry finally to approve the manuscript with a letter to Mrs. Ellen Offner at the publicity department of the press: "The newly assembled and revised NEW NEGRO POETS: USA, which my secretary is now typing is, I think, full of exciting young poetry. It will be on its way to you-all some time next week. Brace yourselves for the black avant-guarde! Some is beatnik, but lots of it is simple and moving, too. I hope your Press will find it feasible to print." (9 February 1963) Two days later he sends a manuscript of 47 poets and 156 poems, and a month later Perry says he likes Vesey, Spellman, Pitcher, and Danner but feels, still, that "most of the others are interesting

more from a sociological rather than a literary point of view." (12 March 1963) He frets as well about Arna Bontemps's forthcoming poetry anthology, although Hughes quickly replies to tell him that the Bontemps book, unlike his, is "a sort of [Louis] Untermeyer catch all covering the last 50 years," and that Bontemps and Rosey Pool "all borrowed from my carbons (with my permission)." (16 March 1963)

Once the book is at last accepted, another important issue arises that has everything to do with the way a body of poetry makes its way to readers. How would the book be arranged? Hughes advocates for straight alphabetical order, but Lou Ann Brower, who is handling this stage of the process for the press, has something else in mind. She arranges the poems into the following sections, in her words: "lyrical, descriptive, personal, and sociological, with a small number of humorous ones that can be sprinkled here and there." (11 June 1963) Hughes refers to this as a "mood arrangement" but asks at least for an index to make a poet's work easy to locate. He adds a tongue-in-cheek response to one mention in her letter, "Incidentally, if you don't capitalize the word Negro, you will make the Afro-Americans mad." (18 June 1963) So the peculiar organization stood as though, after over three years of wrangling, Hughes did not have the energy to advocate. Indeed, the book was no longer his in the way it had been at its conception.

Enter Gwendolyn Brooks. Hughes supported and corresponded with Gwendolyn Brooks for many years. In 1942, before her first book, *A Street in Bronzeville,* was published, Brooks wrote to him, "I greatly wanted to

discuss poetry with you—the modern Negro trends.... and especially your opinion regarding the personalized trends that most of the members of the poetry class are taking." (11 March 1942) Poets were turning away from the idea that black poetry must always be representative and not reflective of the individual or interior life of a black speaker, but rather written for the good of the collective. The pressures on black writers were evident in another Brooks letter from 1942: "Lately I've been writing about the war, so that no one can say of me, SHE LIVED ALOOF FROM HER TIME!" (10 April 1942) They were old professional friends by 1963 when Hughes wrote, "I am off Sunday to the Berlin Festival. One of the younger African poets is denouncing me there, I hear tell—which is a good sign they won't be <u>imitating</u> me as some of the older ones did.... Each generation should be its own different self." (13 September 1964) The humorous highlight of the correspondence came when Brooks, by way of telling Hughes that he underestimated his own celebrity, said "no one could be more mustard-greensy than yourself!" (2 November 1962) This also displayed the value both poets placed in being perceived as "of the people."

It was no surprise that Hughes wanted Brooks to write an introduction for *New Negro Poets,* and when the press balked at paying her full fee he wrote to the press, "whatever the cost beyond what you are prepared to pay, simply charge against my future royalties on the book. I like Gwendolyn's writing and respect her intelligence so much, I think we would get something good from her, and I am willing to help pay for it." (23 September 1963)

Brooks's introduction was dutiful, not imaginative. The odd sections, which she describes in the introduction, dominate the way one enters and moves through the book. The absence of any word by Hughes—especially given that the order was not of his design—leaves the book feeling a bit deflated. The opening (so-called "lyrical") section contains unobjectionable, undistinguished work by otherwise excellent poets, some of whom, like Jay Wright and Audre Lorde, had yet to find their strongest poetic voices. The work without exception would be called "non-racial," as through straining to "prove" that these poets weren't going to bite anyone on the nose and that an exploring white reader could safely enter these pages.

Black poetry had changed in the four years (1960 to 1964) that it took to bring *New Negro Poets* into the light. What seemed to be news in 1960 felt dated and stale by 1964, and in the absence of the sounding board or call and response of a collaborator like his friend Bontemps, Hughes was left alone to defend his territory and the validity of the project, rather than build a stronger anthology. We have, then, an anachronistic anthology of "new" Negro poetry just as Negroes were becoming "black" and the Black Arts Movement was coming forcefully together. The jacket copy, almost certainly not written by Hughes, in part read:

> In the past the Negro writer has preoccupied
> himself with protest literature; his song was a
> cry or a shout, or a sigh of resignation in the face

of deprivation, suffering, and hatred. But with
the racial crisis at a head in America today, and
with increasing support being given to the Civil
Rights movement, it is possible for the Negro
poet to release himself from the traditional role
of social critic. As is evident in these pages, he is
turning now to the universal themes that have
inspired poets of all ages.[16]

It continued, ". . . the 'protest' poetry included here is decidedly more personal than that of the past." The press was trying to present the work as ameliorative and not frightening or too racially challenging.

The anthology did have its standouts: Ted Joans's "It's Time," G.C. (now Gloria) Oden's sophisticated "The Map," Leroi Jones's "Epistrophe," David Henderson's "Sketches of Harlem" and "Downtown Boy Uptown" and Alfred B. (now known as A.B.) Spellman's "John Coltrane: An Impartial Review" and "Zapata and the Landlord." Spellman's work seemed to herald a new day, to sound like the dawn of a new poetics. This is "John Coltrane: An Impartial Review," which might be the first "John Coltrane poem":

may he have new life like the fall
fallen tree, wet moist rotten enough
to see shoots stalks branches & green
leaves (& may the roots) grow into his side.

around the back of the mind, in its closet
is a string, i think, a coil around things.

listen to *summertime,* think of spring, negroes
cats in the closet, anything that makes a rock

of your eye. imagine you steal. you are frightened
you want help. you are sorry you are born with ears.

In a different mode, from Oden's "The Map":

> Europe (also)
> lies fragmented; though from nature's—not the
> mapmaker's—division. Ireland off-
> set from England, offset from France (feigning
> oasis beside the rot-brown fill to
> Germany) supplies one awkward revel
> of abstraction as that gross bud of Spain
> (with Portugal) patterns another; not
> to mention Italy's invasion
> of the sea.

And the star poem, from globe-trotting perennial beat-
nik Ted Joans, "It's Time":

> *It is time* for the United States to spend money on
> education so that every American would be
> hipper, *thus no war!*
> *It is time* for the garbage men to treat garbage cans as
> they treat their mothers
> *It is time* for the Union of the Soviet Socialist
> Republics to raise the Iron Curtain and let
> the world dig 'em
> *It is time* for all museums of art to stop charging
> admission fees

It is time for the electric chair to give birth to an elec-
 tric couch thus enabling the entire family to
 go together

···

It is time for square jivey leagers to stop saying 'he's
 sick, she's sick, they're sick, sick sick sick'

···

It is time for Steve Allen to be the next president of the
 United States, Dizzy Gillespie Sec of State
 and Kim Novak our Minister of Foreign
 Affairs
It is time for jazz and more jazz and some more jazz
 and still some more jazz
It is time for the American Indians to be made multi-
 millionaires
It is time for the keys to be left in the mail box again
It is time for the rhinoceroses to roam the streets of
 Little Rock and spread joy
It is time for a moral revolution in America
It is time for the world to love and Love and LOVE
It is time for everybody to swing (Life don't mean
 a thing if it don't swing) yes that is right
 because
It's time it is time to straighten up and fly right tonight.

New Negro Poets: USA was at last published in 1964,
and the response was not enthusiastic. Hughes's biogra-
pher Arnold Rampersad recounts that the reviewer in
the *Nation* called it "The Sepia Deb Ball in American
'Verse,'" and asked, "Why does an anthology like this
get published? Certainly not for the poems." *Saturday
Review* said it was "a mistake in conception and a failure

in execution . . . all the faults of adolescent poetry are here: trite sentiment, fake simplicity, self-pity, punch lines."[17] I cannot imagine that by the time *NNP* went to press that Hughes had not grown, in one of his favored words, weary, of wrangling not so much with editors—Hughes was long-practiced at that—but rather with white editors' ideas of what a changing black poetry should be: an idea and ideology that was yoked to the rapidly changing times and a lack of integration in the literary world.

In 1960 Hughes was embarking on the road to *New Negro Poets*, but he was also immersed in new work of his own. On 4 July 1960, he began a poem that is different from any other he had written: the great, challenging, misunderstood, funky, allusive, dozens-inspired opus, "Ask Your Mama." It was longer by miles than any poem he had ever written, and it seemed to explode from a wellspring of accrued knowledge and pent-up energy. The poem was carefully musically notated and called out for performance. It was ambitious and brilliant and little understood. It was the "wild hare" inclusion in Dudley Randall's (black) nationalistic anthology *The Black Poets*, which has stayed available in print for so long that it has introduced scores of students to the canon. I think Randall included "Ask Your Mama" because it represented such a different Hughes, a Hughes who could move with the times but who nonetheless sounded only like himself.

At the conclusion of his 1921 preface to *The Book of American Negro Poetry*, James Weldon Johnson notes that his book is the first of its kind, the very first anthology of black poetry. Upon rereading those words recently I

was struck by how short and quantifiable a history it has been, not even a century, and shorter still from the time Hughes set out to make his mark, however imperfectly, with *New Negro Poets: USA*. There was scarcely a moment in Hughes's life when he was not deeply engaged in making different kinds of projects. At the end of his rich and productive life, he was pushing his own voice to a new place and striving to make a space for others, all in poetry, as the times were rapidly changing. And it is fitting that "our" greatest poet understood that it was not enough just to make the work, the raw goods, and let someone else provide the sole avenue of mass production. He understood that an artist of influence is also called to create the context in which the work will be received.

The unwitting "authorship" of anthologies becomes a way, then, to hear a writer's voice when he or she is perhaps least self-conscious about presenting it. In the act of anthologizing, a writer aims to present the voices of others more explicitly than his or her own. Yet the anthology offers a vision of the creative landscape a writer wishes to live in and wants to foster. The anthology is akin to the living room: the inner self revealed though the presentation of the representative space.

But the best of intentions can also be thwarted by the very real exigencies of the publishing companies—almost always white—that enable words to make their way to us. Every generation boasts of its attempts to do its own thing outside of the stricture of white publishing and its often-limited visions of black people. I think of the famous Harlem Renaissance journal *Fire!!* that Wallace Thurman edited with Langston Hughes, Gwendolyn

Bennett, Richard Bruce (Nugent), Zora Neale Hurston, Aaron Douglas, and John Davis; Dudley Randall's splendid Broadside Press from the 1960s forward that brought so much black poetry to the light; Ishmael Reed's multicultural Bay Area Yardbird Publishing Cooperative; Barbara Smith and Audre Lorde's black feminist Kitchen Table / Women of Color Press; Other Countries Press, devoted to black gay and lesbian literature in the early 1990s; Kassahun Checole's Africa World Press, focusing on writing from throughout the African diaspora; and Haki Madhubuti's hardy Third World Press out of Chicago, to offer some varied examples from among many.

And if we remind ourselves that the published word is always mediated in some way, then we are left with the question that Hughes implicitly addressed in his many editorial efforts: How do we create a world in which our vision makes sense? Which means of production do we choose to try to control? Editors, scholars, and publishers are one thing, but cultural context articulated by culture-makers gives us decidedly intimate views of tradition.

MEDITATIONS ON "MECCA":
GWENDOLYN BROOKS AND THE
RESPONSIBILITIES OF THE BLACK POET

◆

In the spring of 1967, Gwendolyn Brooks attended the second Fisk University Black Writers' Conference in Nashville, Tennessee. The times were famously tumultuous: the Tet offensive and the U.S. response had escalated the Vietnam War; the Watts riots ravaged Los Angeles; some of the worst race riots in U.S. history left forty-three dead in Detroit. The Black Panther Party had been founded and Amiri Baraka and others had begun the Black Arts Movement. Just one year ahead, Martin Luther King Jr. and Robert Kennedy would be assassinated, and Medgar Evers and Malcolm X had already been shot down. At the first Fisk Black Writers' Conference in 1966, black writers defining the aims for a new black awareness clashed with Brooks's contemporary, the poet Robert Hayden.[18] Responding to the country's ambient urgency, those writers wanted work that "promote[d] an aesthetic that furthered the cause of black revolution."[19] But Hayden insisted that, when it came to his writing, he was a poet first and black, second. In 1978, he re-stated his view:

> To put it succinctly, I feel that Afro-American
> poets ought to be looked at as poets first, if that's
> what they truly are. And as one of them I dare to
> hope that if my work means anything, if it's any
> good at all, it's going to have a human impact,
> not a narrowly racial or ethnic or political and
> overspecialized impact.[20]

The battle for the eloquent words of black writers to further the cause for black dignity and Civil Rights was on.

In 1967 Brooks was already a highly acclaimed author; she won the Pulitzer Prize for *Annie Allen* in 1949 and had published five books of poems and a novel. She was fifty years old. But despite her stature, the 1967 Fisk conference occasioned her grand rebirth of consciousness. In her autobiography, *Report from Part One,* Brooks wrote:

> I—who have "gone the gamut" from an almost
> angry rejection of my dark skin by some of my
> brainwashed brothers and sisters to a surprised
> queenhood in the new black sun—am qualified
> to enter at least the kindergarten of new con-
> sciousness now. New consciousness and trudge-
> toward-progress.
>
> I have hopes for myself.[21]

Those moving words, "I have hopes for myself," show us a writer open to the urgent cries of younger writers in trying times. But this moment also offers an opportunity to consider how public or communal pressures can dramatically affect the choices writers make in their literary

careers. The 1968 volume, *In the Mecca*, would be Brooks's last book with the mainstream publisher Harper and Row. After this, she would publish all of her books with black houses, and her poetic voice would be more consciously calibrated to an audience that would presumably understand her on street corners and in taverns as well as in universities and recital halls.

Like many young readers, I first encountered Gwendolyn Brooks's work as a child when I found "We Real Cool" in an anthology. Then, as now, the poem's tautness and economy, its repetitions and sense of sound, thrilled and amazed me. As an older reader, I was carried away by *The Bean Eaters* and *A Street in Bronzeville*. Brooks's specialized vocabulary; the magic imbued in kitchenettes, cabbage, and beans; the strange diction that could belong to no one else; the tensile strength of each line; the words I didn't know like "thaumaturgic" juxtaposed remarkably in the same stanza with "black and boisterous" and "bastard roses" in the very same poem where she rhymes "crescendo-comes" with "hecatombs," "banshee" "Gets" and "vinaigrettes," "ribbonize" and "terrifies," "tra la la" and "cinema."[22] If such wild and unexpected curiosities were possible in her language, then anything might be possible for me. No music was too strange for poetry in the path Miss Brooks had cleared. From her earliest work she was clearly committed to honoring the small details of "ordinary" lives and to seeking the plain beauty in surroundings that others would ignore. It would be some years before I would think about the poems that I loved in the context of the times and pressures under which they were written.

Langston Hughes's 1926 essay "The Negro Artist and the Racial Mountain" offers perennially resonant words that name necessary freedoms for black artists. This anthem bears quoting at length:

> We younger Negro artists who create now
> intend to express our individual dark-skinned
> selves without fear or shame. If white people
> are pleased we are glad. If they are not, it doesn't
> matter. We know we are beautiful. And ugly too.
> The tom-tom cries and the tom-tom laughs. If
> colored people are pleased we are glad. If they are
> not, their displeasure doesn't matter either. We
> build our temples for tomorrow, strong as we
> know how, and we stand on top of the mountain,
> free within ourselves.[23]

Black writers know well the perils of white racism and racist judgments against us and our work. Racism is a straightforward, if unpleasant, navigation for any African American. But we are also, as ever, faced with judgments and injunctions from within our community that our work should perform a certain service as well as say and not say what is empowering or embarrassing to "the race" at large. The pressure on creative work can be intense for artists who belong to groups still struggling for their fair shake in society. The challenges to be published and heard, let alone to write well, lead to the understandable conclusion that every word counts. Those who wish for justice for the race would also wish their words could further the cause, however controversially that cause might be defined.

Brooks's *In the Mecca* offers a meditation on the role of art and the artist during troubled times filled with philosophical and strategic challenges for black communities. The recurrent figure of the black poet in the book suggests that Brooks was wrangling with questions of the utility of poetry to a larger community's struggle. She labored on the book's centerpiece poem "In the Mecca" for some thirty years after working, as a young woman, for a "spiritual advisor" named Dr. E. N. French who sold charms and potions in the Mecca apartment building on the South Side of Chicago. Brooks is a master of the shorter lyric. At some 815 lines, "In the Mecca" is the longest poem she has ever published, and it represents a clear turning point in her work and in her ongoing consideration of the role and responsibility of black poets in their communities.

Although an epic, "In the Mecca" is composed of linked portraits and as such is continuous with Brooks's earlier work. From her first volume in 1945, *A Street in Bronzeville,* Brooks has shown herself to be the consummate portraitist, moving through loved and familiar black communities with keen eyes. She creates galleries of individuals who together make up a community. *A Street* begins in medias res: "But in the crowding darkness not a word did they say." Something else has just been said "offstage" that this line counters. Nineteen-forties black Chicago was the subject of much sociological inquiry, what poet Robert Hayden would call "the riot-squad of statistics"[24] that so often describes black life. Brooks's work illuminates many of the people and stories behind narrow, shopworn characterizations of the black urban

poor. "A Street" is singular, specific, though unamed; "in Bronzeville" is named, yet mythical. Like "Harlem" the name signifies more than simply the streets it bounds.

Brooks's relationship to the urban Negro realism of the 1940s, best seen in Richard Wright's *Native Son* (also set in Chicago) and Ann Petry's *The Street*, is discernable. But Brooks's poetry makes a space for something beyond realism as we see in her magnificent "kitchenette building":

> We are things of dry hours and the involuntary plan,
> Grayed in, and gray. "Dream" makes a giddy sound,
> not strong
> Like "rent," "feeding a wife," "satisfying a man."
>
> But could a dream send up through onion fumes
> Its white and violet, fight with fried potatoes
> And yesterday's garbage ripening in the hall,
> Flutter, or sing an aria down these rooms
>
> Even if we were willing to let it in,
> Had time to warm it, keep it very clean,
> Anticipate a message, let it begin?
>
> We wonder. But not well! not for a minute!
> Since Number Five is out of the bathroom now,
> We think of lukewarm water, hope to get in it.[25]

In the first line, "We are things" suggests a people at war with the dehumanization of sociology and poverty who nonetheless constitute themselves as a community, a "we." In the world of this poem, there is no fissure in the day for dreams. "We wonder" and "we think," but we do not have

time, "not for a minute," to dream. "Dream" is never a verb in this poem. But "dream" is also the only word Brooks repeats and the word that lingers in the reader's mouth after the poem is done. She lets her readers experience the high notes of "white" and "violet" before declining into the earthbound, stolid, round vowels of "fried potatoes." We may end with the humble tuber, but "hope" is still the poem's last verb, even if only for "lukewarm water." When a starkly sociological approach to "the Negro problem" was the order of the day even in some black circles, it was bold of Brooks to name the imagination as a site worth tending, to honor the space of the *dulce* to go along with the *utile*.

The characters in "In the Mecca" are linked through the geography of living in the Mecca apartment building at the time of a great tragedy that unfolds as the poem progresses. Brooks's choice of epic to tell this community's woeful tale is particularly effective. The lack of aeration—the poem is not sectioned—emphasizes the claustrophobia of the world Brooks portrays. At some moments, the poem feels pasted together with set pieces that are not quite sure of why they are where they are in the poem, or why they are in the poem at all. But if we return to our earlier model of the Brooks poem as the community slice of life, at any given moment you could open any door in the building (any section or stanza), at any time, and find anything; anything except what is most dearly sought, that is, the missing girl-child "Pepita" who, in the grisly end, we learn "never went to kindergarten . . . / never learned that black is not beloved."[26]

But that puts us ahead of the story in the poem. "In

the Mecca" begins with epigraphs about the ironically named Mecca apartment building, once a showplace, now a decrepit ruin. No one knows how many live there, and danger lurks within. Brooks quotes one Russ Meek in her last epigraph: "There comes a time when what has been can never be again." We first encounter Mrs. Sallie, a "low-brown butterball" with an apartment full of children surviving on ham hocks and "a spoon of sweet potato." St. Julia is parodied for her excessive credence in God: ". . . He's the comfort / and wine and picallilli for my soul. / He hunts me up the coffee for my cup. / Oh how I love that Lord." Prophet Williams is the "spiritual advisor" "who reeks / with lust for his disciples" as he peddles potions to the Meccans. There is Way-Out Morgan who "smacks sweet his lips and adds another gun / and listens to Blackness stern and blunt and beautiful, / organ-rich Blackness telling a terrible story." And there is great-great Gram who is still remembering slavery, providing a historical long view and example of the persistence of community memory.

Brooks presents these characters and many others, until the uppercase crisis of the poem: "WHERE PEPITA BE?" One of Mrs. Sallie's children has gone missing. The mother searches from apartment to apartment; no one has seen the girl, most are indifferent, and it turns out that "Beneath [Jamaican Edward's] cot / a little woman lies in dust with roaches," murdered. The poem ends, its conclusions echoed later in the book:

And they are constrained. All are constrained.
and there is no thinking of grapes or gold

or of any wicked sweetness and they ride
upon fright and remorse and their stomachs
are rags or grit.

The character of Alfred, Mecca-dweller and would-be
poet, is a key to considering Brooks's thinking on the role
of poetry in times of communal crisis. At first glimpse
Alfred is exultant from the labors of poetry-writing:

> To create! To create! To bend with the tight intentness
> over the neat detail, come to
> a terrified standstill of the heart, then shiver,
> then rush—successfully—
> at that rebuking thing, that obstinate and
> recalcitrant little beast, the phrase!
> To have the joy of deciding—successfully—
> how stuffs can be compounded or sifted out
> and emphasized; what the importances are;
> what coats in which to wrap things.

Brooks then abruptly informs us, "Alfred is un- / talented.
Knows." The excitement of struggling to craft verse is
undercut by Alfred's artistic impotence. While Mrs. Sallie
is frantic to find Pepita, Alfred is busy mooning over the
work of the Senegalese poet and politician Léopold
Sédar Senghor who, despite the wisdom of his words,
is imagined "in Europe rootless and lonely." Alfred
rhapsodizes, "To be a red bush! / In the West Virginia
autumn" in the midst of the chaos that is the decaying
Mecca building, the building standing in both for the
country that is literally burning and falling apart and for
the black community that has no choice but to somehow

hold together. In the drama of the poem, the little girl is the hope of Negro tomorrow, the "little seed" who is missing in the warrens of the Mecca. "No, Alfred has not seen Pepita Smith," Brooks writes, "But he (who might have been a poet-king) / Can speak superbly of the line of Léopold." Dead Pepita speaks in memoriam, and her poetry is utterly useless: "'I touch'—she said once—'petals of a rose. / A silky feeling through me goes.'"

The black nationalist poet Don L. Lee (now known as Haki Madhubuti) makes a mysterious but instrumental appearance in the poem. Among residents he is the lone non-Meccan. Lee serves as a foil to insignificant Alfred:

> Don Lee wants
> not a various America.
> Don Lee wants
> a new nation
> under nothing;
> and . . . wants
> new art and anthem; will
> want a new music screaming in the sun.

Lee's section is lean and clean and imagines a contemporary black poetry that is "new," relevant, and can move people to "music" and "screaming" at all that demands outrage. This seems like a refusal of the pre-1967 Brooks in favor of the new Brooks with hopes for herself and her work. Yet there is something about Brooks's treatment of Alfred that saddens me. His exultant love of poetry itself and veneration of the sweat of the craft feels familiar and exciting, a pleasure I know myself and wish

for others. It is that joy and struggle that is the work of writing. Context is, of course, all-important, and Brooks has placed Alfred's exaltations in the midst of far more urgent matters indeed. He is a rather silly man. But I wanted Brooks to transform him into a poet-hero, perhaps by his finding in the words of the poets he has read something that offers direction or succor to the community as it struggles through the crisis of Pepita. Poetry can and does have that function and possibility, just as there are also many poets who lose themselves in stardust while the world falls apart around them. Worse still, some poets claim themselves exempt from the responsibilities of citizenship—to tend to one's community, to turn some portion of one's energies and talents to the good of that community—in the name of the apolitical sanctity that they assert is the domain of poetry and art.

The rest of the book, *In the Mecca,* forms a crucial follow-up to the long opening poem. In it, the figure of the poet and the role of the poem are developed and then redeemed. The poet is more explicitly Brooks herself, in the midst of a black community, offering words that both mark the times and gain her a place among her people. The second section is called "After Mecca," and the first poem is "Boy Breaking Glass." The boy cries, "I shall create! If not a note, a hole. / If not an overture, a desecration." The occasional poems, "The Chicago Picasso" and "The Wall," commemorate events that took place two weeks apart in Chicago in August 1967, one downtown—the dedication of a Picasso statue to the city—and the other on the city's black South Side—the dedication of "The Wall

of Respect," a mural with portraits of black heroes. "*All* worship" [emphasis mine] at "The Wall:"

> I mount the rattling wood. Walter
> says, "She is good." Says, "She
> our Sister is." In front of me
> hundreds of faces, red-brown, brown, black, ivory,
> yield me hot trust, their yea and their Announcement
> that they are ready to rile the high-flung ground.

The black community is shown multitudinous and varied, but nonetheless, unified and, crucially, embracing of the poet, Brooks herself, whose contribution is useful and welcomed. Her poetry has been explicitly accepted and has helped the people become "ready to rile." The last stanza is a single line, "And we sing." The poem and the event have helped reunify the community that is so shattered at the end of "In the Mecca"; there is a choral voice and a self-articulation as "we," which is certainly the first step in understanding oneself as part of a larger whole with common aims. The audience is not passive like the downtown audience at the Chicago Picasso dedication: "(Seiji Ozawa leads the Symphony. / The Mayor smiles./ And 50,000 see.)" The downtowners are parenthetical here and make no noise, joyful or otherwise. Brooks is no stranger to commemorative, occasional poems, having written prefatory, tributory poems to her brother, father, and black war heroes. But the act of writing in tribute and on occasion assumes greater meaning and context after a black community has been shown in urgent need of reparation.

But the "we" is never without its complications and shortfalls. Some members of the same community of black poets who embraced Brooks and took her to a new stage of black consciousness were brutally judgmental of Robert Hayden. Yet his 1970 collection, *Words in the Mourning Time,* presents some striking points of comparison to *In the Mecca.* Just a few months after Brooks's poems for the Chicago Picasso and the Wall of Respect, Hayden delivered an occasional poem, "And All the Atoms Cry Aloud," in Evanston, Illinois, for the Baha'i centennial. In *Words* Hayden mourns the country's racial woes as he mourns the Vietnam War. Both poets' books include Malcolm X poems. Hayden's Malcolm is a great man because of his spiritual salvation rather than racial deeds or rhetoric. "El-Hajj Malik El-Shabazz" concludes: "He fell upon his face before / Allah the raceless in whose blazing Oneness all / were one. He rose renewed renamed, became / much more than there was time for him to be."[27]

In Brooks's Malcolm X poem in *In the Mecca,* it is Malcolm's black "maleness" that makes "us" "gasp" and characterizes him as someone to be revered, followed, and admired. Hayden is always interested in the spiritual strivings and human links that he believes invite transcendence and liberation. Brooks closes *In the Mecca* with two "sermons" addressed to "[m]y people, black and black," an audience Hayden would neither name nor presume. In "The Second Sermon on the Warpland" Brooks writes: "This is the urgency. Live! / and have your blooming in the noise of the whirlwind." Although she may think of the book's final words as evidence of her move toward a

new understanding of her voice and responsibility as a black poet, she had sounded similar notes in 1949 to end her book *Annie Allen*: ". . . Rise. / Let us combine. There are no magic or elves / Or timely godmothers to guide us. We are lost, must / Wizard a track through our own screaming weed."[28] The two authors' common concerns circa 1970 are worth noting, because at the time Brooks might have been seen as the "blacker" poet and Hayden as the "spiritualist," neither characterization completely accurate.

The expectations placed on black poets by a larger public are one thing. The demands of one's own people—however vexing it can be to draw perimeters around that populace—have always been another. What does the race want from its poets? Different and usually unpredictable things, in my experience, and often nothing but the particular vision a particular poet has to offer. Who is "the race," anyway? Yes, there are literary schools and establishments, but certainly no central committee deciding who is "in" and who is "out." Calibrating these influences is close to impossible, inevitably imprecise, and drains good energy from the work of writing poetry.

But I am sure I am not alone in wanting my own work to be useful, to find a voice that speaks to people and communities beyond myself. I have seen my work overpraised by narrow-minded white critics who seem relieved that some of my references and formal choices are familiar to their own cultural milieu. I have seen my work criticized small-mindedly by more than one black woman elder poet—the same poets I imagined would

be pleased by it. Many audiences I read to are mostly segregated; I've been greeted with silences both appalled and appreciative by white audiences, been met with suspicious stares and raucous love by black audiences. I've been left out of anthologies and gatherings where I felt I should have been included and included where I felt my work couldn't possibly belong. I am most often surprised by who finds and appreciates my work, and for what reasons. I believe that poetry readers are largely eclectic and single-minded.

But the love that has meant the most, I have to say, has come from the diverse black communities who I feel "get it" on myriad levels, who see what I am trying to do with words and with message. I do not seek their approval when I write, but it pleases me when it comes, to echo and revise Hughes. When students ask me about the difficulties of writing poems that may reveal delicate family matters, I always tell them to write the poem and worry about who reads it later. I do not consider it a betrayal of my muse to say there are a few poems that I might write but not read or publish in certain forums because I felt—imagined?—they would cause harm to that amorphous group called black people, poems that might perpetuate dangerous stereotypes if taken drastically out of context. How many African Americans have modified what and where we say or do because we think it would reflect badly on "the race"? What if these considerations do not make us prudish but rather indicate that there are familiar issues and degrees of self-censorship that we are faced with because of our history, and that our public acts

are sometimes appropriately strategic? Such awareness can be separated from the fundamental work of internal liberation that is central to the poetic process.

What does all this have to do with *In the Mecca?* The book has taught me that none of us lives outside of historical moments or quotidian pressures and concerns. The historical challenge to understand context in which the elders of our tradition had to labor to make their voices heard is unusually pointed for black writers, and thinking about 1967, Brooks, and Hayden helps us do so. Before the famous paragraph from "The Negro Artist and the Racial Mountain" that opens this essay, Hughes wrote something else that bears consideration. "An artist must be free to choose what he does, certainly," he wrote, "but he must also never be afraid to do what he might choose." Brooks never feared or shirked what she fervently believed was her responsibility; that sense of responsibility shaped her very aesthetic. Few poets walk with such integrity. Brooks's career in 1967 reminds us that the matter of listening to the muse, of being utterly "free to choose," is always interrupted by larger concerns that can at times come to constitute the muse's voice. Whether those concerns are catalysts, straightjackets, or something in between is open to debate.

"I AM; I'M A BLACK MAN; / I AM:":
MICHAEL HARPER'S "BLACK AESTHETIC"

◆

1.

In his 1969 introduction to the anthology *The New Black Poetry*, Clarence Major wrote:

> We know that without a new, radical and black aesthetic the future of black people shall be empty. The progress of this new vision of the world, a black vision, broadens and deepens the beauty of this nation, of the world. The only really unfortunate aspect of the whole situation is that the dominant white society has been brainwashed into seeing the black upheaval as a negative force.... Nobody has told America more eloquently than black poets how it can save itself, but America is deaf.[29]

The next year, a young black poet named Michael S. Harper began a formidable publishing streak with five collections published in as many years. Harper's voice has evolved over the last thirty years (see *Songlines in Michaeltree: New and Collected Poems*[30]), but his articulation of a wounded America in need of salvation remains consistent.

When Clarence Major wrote those words, and when Michael Harper began publishing his work, the Black Arts Movement offered the most visible manifestation of a new black voice. But I say "visible" with care, for one of the surprising offshoots of the career of Michael Harper is how his collected work urges us to tell the story of that period somewhat differently. Amiri Baraka, formerly LeRoi Jones, is the most prominent exemplar of that movement, and certainly his work has articulated and embodied a "Black Arts" philosophy. Kimberly Benston reminds us, in his study *Baraka: The Renegade and the Mask,* "while Jones was still toiling in the wasteland of America's 'mainstream' avant-garde, several black innovators were already sowing the seeds that later sprouted as the Black Arts Movement. Such figures as Askia Muhammad Toure (formerly Roland Snellings), Daniel H. Watts, Bobb Hamilton, and Hoyt Fuller were actively working toward a nationalist aesthetic in the early 1960s."[31] Along with Baraka, Don L. Lee (Haki Madhubuti), Larry Neal, Sonia Sanchez, Mari Evans, Ed Bullins, and Carolyn Rodgers, among others, would appear in most rosters of Black Arts Movement writers.

In 1968 in *Drama Review,* Larry Neal put forth the movement's philosophy, which dominated late 1960s and early 1970s thinking about black creativity and responsibility. It began,

> The Black Arts Movement is radically opposed
> to any concept of the artist that alienates him
> from his community. Black Art is the aesthetic
> and spiritual sister of the Black Power concept.

As such, it envisions an art that speaks directly
to the needs and aspirations of Black America.
In order to perform this task, the Black Arts
Movement proposes a radical reordering of the
western cultural aesthetic. It proposes a separate
symbolism, mythology, critique, and iconology.
The Black Arts and the Black Power concept
both relate broadly to the Afro-American's de-
sire for self-determination and nationhood.[32]

The demands that these black writers were placing upon
one another were clear and in the spirit not only of the
turbulent times but also of black literature to date. While
black literature comes in a full range of flavors, black au-
thors have nonetheless always labored under the demand,
implicit or not, that their literature be of service and
speak for "the people."

African American literary historiography also casts the
Black Arts Movement as the banner headline of the 1960s
and early 1970s. *The Norton Anthology of African American
Literature* (edited by Henry Louis Gates Jr. and Nellie
Y. McKay), to choose one prominent and best-selling
example, calls the section of literature from 1960–1970,
"The Black Arts Movement," and the section that fol-
lows, "Literature since 1970." This is not an inaccurate
way of characterizing these years, and anthologists are
always faced with distinctions that can lack nuance when
it comes to the crude business of categorizing. But in the
Norton anthology Paule Marshall who first published
her masterwork *Brown Girl, Brownstones,* in 1959 and
Reena and Other Stories in 1962, is placed in the post-1970

category, presumably because of the popular Feminist Press reissue of *Brown Girl* in the 1970s. Audre Lorde is also in that "since 1970" section—again, her poetic and nonfiction output in the mid- to late-1970s is how we know her best. But Lorde's first book of poems, *The First Cities,* appeared in 1968, and *Cables to Rage* in 1970. We find Lucille Clifton in the post-1970 section when her first collection of poems, *Good Times,* appeared in 1969 to great acclaim. June Jordan published her first collection, *Who Look at Me,* in 1969. Alice Walker's first collection of poems, *Once,* appeared that same year. Another "post-1970" voice in the Norton anthology, Adrienne Kennedy, in fact saw her most renowned Surrealist-influenced play, *Funnyhouse of a Negro,* in a successful off-Broadway run in 1964, the same year of Amiri Baraka's (then LeRoi Jones's) Obie-winning play, *Dutchman.* The Norton anthology reasonably places a significant pantheon of feminist voices in the 1970s rather than the 1960s, when they emerged.

But this categorization denies their challenge to the often-patriarchal and male-dominated vision articulated by many in the Black Arts Movement. In other words, a tidier conversation has been manufactured that does not show the contending views that, in fact, developed simultaneously. The anthology *Black Fire,* the Black Arts Movement's early bible, edited by Neal and Baraka, included only eight women in its roster of eighty-seven contributors. Indeed, one could look at the black feminist publishing boom of the 1970s as a response to the patriarchal aspects of the Black Arts Movement. But it is important here to be precise about who was writing what when and to rethink the way those years have been canonized.

Of the male poets in the late sixties (and when I say late sixties, I mean a period that moves forward into the early seventies) two are worthy of note. Jay Wright published his first collection, *Death as History*, in 1967. And then there is Harper.

I'm not splitting hairs with the editors of the Norton anthology so much as I am using the book to make an example of the widespread phenomenon of remembering—indeed, canonizing—"the sixties" in black literature as a time when a certain kind of black voice reigned and those who didn't pass the litmus test were marginalized from the conversation. What happens when you put the feminist voices and sensibilities of Clifton, Jordan, Walker, and Lorde next to *Black Fire's* selections? And what happens when you take the work of poets like Michael Harper and Jay Wright and think of them not only as the heavyweight champions of black poetry that they clearly are today (each brings out *Collecteds* in 2001), but also as new voices engaged in the heart of a new black aesthetic that was articulated in the late sixties? Although they are not Black Arts writers per se, and they are rarely discussed in the context of a larger literary moment, they nonetheless are fully engaged with issues of black identity, black pride, jazz and jazz musicians as subject and metaphor, black masculinity, and black history.[33]

Wright and Harper offer a new Afro-sectarianism to African American poetry: a poetry of black progress and righteousness that engages questions of violence, but that is also, in Harper's own words about his work: "informed by European aesthetics, but consistent with African modalities and contained in fresh space with no

reference other than to its internal oneness." A true Black Arts poem could never let the seams of its "European aesthetics" show; look at the attempt in Baraka's work to purge—at least visibly—the so-called European aesthetics from his work until he was no longer even a black Beat poet nor an Afro-Surrealist. So while Harper, albeit in hindsight, articulates a difference between his work and the more doctrinaire work of the Black Arts Movement, he simultaneously opens up a conversation about the ways in which we can more richly understand his work in conversation with that branch of the tree. How different is Harper's "America needs a killing" from Nikki Giovanni's "Nigger / Can you kill / Can you kill"?[34] Think of the richness of a conversation that places Harper's "Brother John" with its riff on "I am a black man" and "I am" with Sonia Sanchez's exploration of a black female self and sensibility in her 1969 "personal letter no. 2": ". . . i am what i / am. woman. alone / amid all this noise."[35] Or the vision of "black power" set forth by Ishmael Reed in the late 1960s in "black power poem," "the spectre of neo-hoodism."[36] Reed looks to the power of "conjure," which is to say the historical and ancestral sources of power, some explicitly religious (santería, candomblé, vodun), which have guided and sustained legions of black people for centuries. He reminds us of the importance of locating black power in what we might call the spirit realm, and, implicitly, in the underdog's power of humor, which shoots through all his work.

The aim here is to keep our literary history sharp and clean, and to demonstrate the range of perspective that has always been part of the conversation about black aes-

thetics. How do we define, and what exemplifies, "a new, radical black aesthetic," in Major's words? And how is Michael Harper's poetry new, and radical, and black?

2. THE MUSIC, *JAZZ*, COMES IN

In Harper's first five books from the early seventies, we see a new black poetry that, in a literal sense, has many continuities with much of the work of the Black Arts Movement. But Harper was also coming from a distinctly Ellisonian locus: America—its vastness and crisscross, infinite variation and hybridity—was one of his subjects as well. Indeed, these poems can be seen as a gesture toward embodying what Albert Murray would call "Omni-America," not in the interest of "proving" the African American's American-ness, or the Negro's full citizenship in the polis (Harper's proud work clearly and continually gestures away from anything resembling that), but rather to give a true sense of the speaker himself and African America itself. The poet's moves from Brooklyn to Los Angeles in the 1950s and then to the heartland of Iowa for graduate school are clearly traceable in these poems. Harper is acutely aware of the topography, demography, and groove of various parts of the country as they have carried meaning both for himself and for black people in general. The richly varied exploration and articulation of a geographical African American American-ness is Harper's charge.

Take, for example, the untitled poem-chant that frames *Songlines in Michaeltree* as preamble and postscript. It announces and concludes the Harper project

of healing a diseased American-ness. Tercets of repeated lines snake down the page: "When there is no history" "there is no metaphor;" "a blind nation in storm" "mauls its own harbors:" "sperm whale, Indian, black," "belted in these ruins." "Sperm whale, Indian, black" places Harper in the Melville via Ellison school of thought, but "belted in these ruins" takes us somewhere else. The polis is "ruined" but held tight, "belted," left to figure out a common destiny, and also left to "belt it," that is, sing it, as the poet here chants and will sing and inhabit the voices and personae of the jazz musicians he so cherishes and regards as America's true pioneers and troubadours. The musicians literally crisscross the country for their work and with sounds rather than words understand and articulate something about the distilled quality of American-ness that is found there.

In "Driving the Big Chrysler across the Country of My Birth" the final stanza's anchor points are geographical, and African American in their specifications:

> What does Detroit have to give my music
> as elk-miles distance into shoal-lights,
> dashes at sunrise over Oakland:
> Elvin from Pontiac, McCoy from Philly,
> Chambers from Detroit waltzing his bass.
> I can never write a bar of this music
> in this life chanting toward paradise
> in this sunship from Motown.

American "Detroit" becomes African American "Motown" by the end of the stanza, in an answer to the question,

juxtaposed with the surprise of the more pastoral images of "elk-miles" and "shoal-lights," which move us from the center of the country to its watery edges with other American creatures covering the country's great territory. "What does Detroit have to give my music" is here asked by an imagined John Coltrane as he travels cross-country with his famous quartet. How does this sense of geography make a map for Harper's poems as these black cats come together to make a sound so distinctly and only of this place, a sound that transcends so much to "chant . . . toward paradise," a paradise that is yet unachieved?

Jazz poems form a genre unto themselves in much American poetry (see, for example, Yusef Komunyakaa and Sascha Feinstein's two volumes of *The Jazz Poetry Anthology,* as well as Art Lange and Nathaniel Mackey's *Moment's Notice*), and within that genre the John Coltrane poem is a category unto itself. Wanda Coleman's "Cousin Mary," David Henderson's "A Coltrane Memorial," Mackey's "John Coltrane Arrives with an Egyptian Lady," Amus Mewr's "The Coming of John," and Sonia Sanchez's "a / coltrane / poem" are just a few examples. Kimberly W. Benston, in his landmark 1989 essay "Performing Blackness: Re/Placing Afro-American Poetry," speaks to the significance of Coltrane: "What we witness is the metamorphosis of Coltrane into 'Trane,' of man into archetype." And he continues to characterize the Coltrane poem as:

> that genre of modern black poetry in which the topos of performed blackness is felt most resonantly. . . . The Coltrane poem traverses the path

of loss, outrage, and restitution through a series of
beginnings and prevented closures. It attempts
to reorder a world from which Coltrane's spirit
is suddenly withdrawn. Yet, it also undertakes
this task as a struggle in and with received poetic
form, specifically, the classical mode of pastoral
elegy.[37]

So it is through the figure of Coltrane—who died in 1967
at forty-one, in a time of so much national struggle and
in his own prime—that African American elegy most
fulsomely takes place for a generation of poets. And
how interesting, given the cant of the times, that it is the
black artist who, like Harper or Hayden, points toward
transcendence of racial identity without abandoning or
sacrificing racial identity.

Harper-as-jazz-poet is distinct in voice from Baraka,
or Al Young, or A. B. Spellman, or Jayne Cortez, to name
a few of his (roughly) generational peers. His jazz voice
is preoccupied with biography and history as poetic con-
text. Harper is, to my mind, the indisputable king of the
Coltrane poem, returning over and over again to Coltrane
as subject matter, motif, engine, inspiration, meditation.
By my count Harper has written twenty-one poems with
Coltrane at the center; he has thoroughly digested and
reinterpreted the man's music. He explores Coltrane in the
mode of "A Love Supreme," "Cousin Mary," and "Naima":
the soulful, moving-toward-spiritual 'Trane who deeply
interprets the blues. In these poems Harper connects
with a very modern blues, a blues that does not call itself
"blues," but is the only vehicle with which a parent could

possibly write about "two sons gone," as Harper does, or the only eye that could examine the racial violence that yields "sex, fingers, toes / in the marketplace," souvenir parts of a black man's body for sale after a lynching. Coltrane via Harper gives us a new blues for new times, and a blues for the Black Arts era as well, a blues that knows and sees what years of history have wrought on the racial front, which is, of course, the American front. Harper has clearly learned a great deal about the blues and poetry from his cherished elder, Sterling Brown, but his blues are his own: resolutely postmodern, literary, and new.

In the legendary "Brother John," which opens *Songlines in Michaeltree* and which opened Harper's first collection, *Dear John, Dear Coltrane,* Harper's very first lines herald the beginning of a project: "black man:". The colon announces the poem will tell us who that particular black man and who the genus "black man" might be, could be. Because of the blank space of the following line break, "black man" will be defined and will also remain open to description, possibility, and interpretation. The poem twists and turns like the Coltrane solos it quotes, invokes, and engages: "I'm a black man; / I'm black; I am—/ A black man; black— / I'm a black man; / I'm a black man; / I'm a man; black— / I am—." Punctuation works overtime in this poem; there are no periods. The black man himself and the "black man" as such are works in progress, unfinished, striving to fully become, to enter the philosophical space of the articulated "I am."

Let's move through the first lines of the poem. "I'm a black man" semicolon: black maleness is a phrase, one

part of me. "I'm black; I am" dash: I am a self fragmented, in medias res; there is more of me to come. "A black man; black" dash: blackness itself a concept in progress. He repeats "I'm a black man" semicolon more often than any other line. And the poem ends with the powerful declaration, "I am" colon: blank space, to be written, narrated, and lived. Unprecedented and unknown, this is self as Self and this self brings with it "black man" from the rest of the poem. Jazz geniuses mighty and complex are the clear subjects of this poem: "Miles," "Bird," and "Trane," who need no further introduction and whose collective flawed brilliance is legend. The other subject is the unknown black everyman "Brother John" who "plays no instrument; / he's a black man; black; / he's a black man; he is / Brother John; Brother John—" The poem calls to mind the iconic march signs of the Memphis sanitation workers' strike of 1968 (Martin Luther King Jr.'s assassination occurred during that strike). Those signs, which read "I *Am* A Man," surely would have been in Harper's mind's eye, as he wrote the poem in the same era. Typically, a Harper poem is densely packed with historical allusions that fall out of any poem if you give it the slightest shake.

Harper's jazz quotes are not merely quotations that lie flat within the poems. Rather, they take on their own life, meaning, and song inside the new walls of the poem. An example is "Last Affair: Bessie's Blues Song," where the Empress of the Blues's famous refrain that begins, "Can't you see / What love and heartache's done to me" becomes a stanza Harper juxtaposes against the story of Smith's death from a 1937 car accident and the long-standing rumor that a white-only hospital refused to treat her:

Disarticulated
arm torn out,
large veins cross
her shoulder intact,
her tourniquet
her blood in all-white big bands:

Can't you see
What love and heartache's done to me
I'm not the same as I used to be
this is my last affair

"Disarticulated" is a Harper coinage that deserves pause.
It resonates with the preface-poem to the book: an
America wished pure but never so, an utterance caught in
the throat, once "articulate" but somehow corrupted and
inaccessible by racism and violence as "history." The voice
of the first stanza contrasts with the blues-turned-verse
of the second. Harper may have learned this from his be-
loved Gwendolyn Brooks who (like Harper), despite her
formal fidelity and precision, also reconfigures the blues
on the page. Brooks's blues poems and Harper's blues
poems are not always immediately identifiable as such,
in the way that the blues poetry of Brown or Langston
Hughes is. But Brooks and Harper both process the blues
in a way that gets at the deep reaches of the music's emo-
tional registers.

Harper's former Brown University student, Gayl
Jones, in her masterpiece novel *Corregidora,* explores a
black female protagonist's inability to feel in the face of
overwhelming pain that is simultaneously intimate and

historical: the legacy of the raped daughters of the brutal slaver Corregidora. To feel that pain is to articulate that truth, to say what happened and sing its song on the way perhaps to transcendence but also through pain to wherever that someplace else might be. When Harper writes, "there is no substitute for pain," he is revealing pain that makes you whole, pain that makes you clean, pain that leads to catharsis, pain that says you see, and it is in jazz that he finds the articulation and transcendence of that pain that is collectively American.

Harper has also fully digested the great music, jazz, and puts forth over and over again the wry paradox of a music that redeems and saves but leaves so many of its makers behind:

> this year's for Charlie Parker,
> born sixty years ago in August,
> died my senior year in high school—
> nobody knew his tunes where I ate my lunch
> with the sansei boys just out of camp.

The music is also an avenue to remembering, in this case, fragments of an Afro-American childhood in the 1950s in Los Angeles, like this from "Pulp Notes":

> I dreamed myself
> learning to play at my own
> funeral, in dress pants,
> pimping in the gallery,
> leading the blind to the trough

where all could drink:
tinkering with homemade radios,
invited to concerts on campuses,
where I was learning to read,
enough good music to play
in the bodies of the women
I came to know in the ballads,
forgetting how to keep myself alive.

Harper animates and exhausts Coltrane. He returns and
returns to him over the course of many years. He writes
about and out of Coltrane, even incorporates Coltrane's
voice into the poem "Dear John, Dear Coltrane," in which
Harper as Coltrane sings the essential refrain "a love su-
preme" when the poem is performed. Think of the jagged
cut, the move from the sung "love supreme" to "sex, fingers,
toes, in the marketplace." Harper is Coltrane with history,
politics, and anger; where Coltrane mourns, Harper rages.

Coltrane died about when Harper started publishing,
which is not inconsequential. The poems channel the
paradoxical sadness of a man who overcame the demons
of addiction and survived a racial apartheid that felt like
it might be about to shift. But he died anyway. Harper
is always trying to join suffering with the transcendence
of music, and it is a conjoinment that he accomplishes
often grammatically with his favored colon. What does
the colon do? It announces something to come. It sets up
comparison. It is the grammatical performer or index of
metaphor. Quotation, explanation, example. But it also
marks ratios, the relationship of one thing to another that

the reader can measure by weighing what Harper puts on either side of those colons.

What can transcend the madness that is the ongoing blight of racial violence and universal apartheid inequities as well as the infinite grief of the loss of not one but two sons, as well as a young brother? Harper seems to be saying: the music is the only way through this, and the music is the holy place, created and offered by figures as large and complex as this flawed country itself. Taken individually, Michael Harper's poems might not seem akin to Coltrane's great numbers. The Harper poem is relatively short and terse. But if we look at the body of Harper's work and see the preponderance of repeated and varied motifs, we might think of the whole body of work as Coltranesque in the sense that Harper's poetry prismatically shifts the way we see those motifs as they change over time and through perspective and context. The Coltrane wail as sounded in the Harper poem is a lament so deep it seems sometimes not to have words and needs "music great enough to bring me back," that is, music that is wordless, of the belly, of the keen, wail, shout, or moan. Harper makes poems with words that do the wordless work of visceral expression.

In Philadelphia, the great saxophonist is remembered with the John Coltrane Memorial Garden, which, last time I looked, was a scraggly, desiccated patch of neglected flora behind a padlocked chain-link fence. Yet the simple majesty of that name and its promise—both realized and failed—tells the story that is his and that Harper has taken on. It is a story of aspiration, of beauty in decaying and decay, of the souring beauty of black men and

their art, or the poignancy of ruin, as in "Dear John, Dear Coltrane's" penultimate plangency: "So sick/you couldn't play *Naima*, / so flat we ached / for song you'd concealed / with your own blood, / your diseased liver gave / out its purity, / the inflated heart / pumps out, the tenor kiss, / tenor love." Coltrane and Harper see the real beauty of ruin without romanticizing it, and they refuse to neglect it. I once drove all over Philadelphia looking for Coltrane's famous "Cousin Mary's" house and there it finally was, a house like any other falling-down Philly row house, no museum or mausoleum but somehow akin to the Harper grammatical colon: possibility and what-is-next, marked, unwritten, an open mouth about to sing or to shout.

3. LOVEFRUIT

In his first two books, *Dear John, Dear Coltrane,* and *History Is Your Own Heartbeat,* Harper includes another group of poems for which he is recognized: poems that chronicle the death at birth of two sons, the birth of a subsequent son who survived, and the redemptive power of the music to bring the speaker out of the enormity of that grief. I was tempted to say that this was rare subject matter for an African American male writer to take on, but I had to pull myself up short when I remembered— and felt echoes of—W. E. B. Du Bois's "Of the Passing of the First Born" in his *The Souls of Black Folk* from 1903. Du Bois, on his "golden" baby's burial day, encounters passersby who call his family "niggers." Even in the deepest and most private of grief the racialized world intrudes, as it does in Harper's work. Indeed, in one of

Harper's poems on the death of the babies he invokes
Du Bois, exploring how, in the face of the death of two
sons, the spectre of race is still present. The death of these
two black male children in a turbulent era in the country's
racial history is metaphor for the racial "disease" and "rot"
that plagues the nation and that the power of jazz music
attempts to transcend.

The title "Reuben, Reuben" by itself utilizes the repe-
tition of the blues or of a keen, the name repeated when
there is nothing more to say: Reuben's Blues. And then,
the declaration:

> I reach from pain
> to music great enough
> to bring me back,

It is as if the death of the son becomes the example, the
object lesson through which the true power of what
Harper will later specify as "the music" can be tested. Then
the peculiar language of grief and its physical distortions
enters the poem:

> swollenhead, madness,
> lovefruit, a pickle of hate
> so sour my mouth twicked
> up and would not sing;

The composite words "swollenhead" and "lovefruit" in-
vent a language for the body that is not as it should be, out
of bounds and articulation. The poem concludes:

there's nothing in the beat
to hold it in
melody and turn human skin;
a brown berry gone
to rot just two days on the branch;
we've lost a son,
the music, *jazz,* comes in.

In "Deathwatch," Harper uses the remarkable, awful descriptive language specific only to the occasion of a child dying:

Just under five pounds
you lie there, a collapsed
balloon doll, burst in your
fifteenth hour, with the face
of your black father,
his fingers, his toes,
and eight voodoo
adrenalin holes in
your pinwheeled hair-lined
chest; you witness
your parents sign the autopsy
and disposal papers
shrunken to duplicate
in black ink
on white paper
like the country
you were born in,
unreal, asleep,
silent, almost alive.

We know that the mother is white and the father is black—"the face / of your black father" and child "like a black- / stemmed Easter rose / in a white hand"—and we know that these poems are written emerging from the late sixties in the United States, so there is a specific context for the racialization of a black and white child and his death therein. Here the union of the "child gone to rot" and the racial, national moment are made most explicit.

Finally a child survives in these poems in "Love Medley: Patrice Cuchulain." The poem first employs a language that sounds like anything but love; it is Harper's clinical language once again, the language of the hospital, its tools and instruments a strange catalogue:

> "Stirrups, leggings, a stainless
> steel slide, a dishpan, sheet,
> a thread spool, scissors,
> three facemasks, smocks, paper
> overshoes, a two-way mirror, dials:"
> the head and left arm
> cruise out, almost together,
> and you drop into gloves,
> your own ointment
> pulling your legs
> binding your cord; the cheesed
> surface skin, your dark
> hairless complexion, the metallic room,
> orchestrate and blow up your lungs,
> clogged on protein and vitamins,
> for the sterile whine of delivery
> room and your staff of attendants.

It is free exercise when the cord's
cut; you weigh in for the clean up
as your mother gets her local
for her stitches: boy, 6 lbs.13 oz.

The long first sentence in this long first stanza builds up
the terrible suspense: another birth story, another black
boy coming into the world, and how will this story end?
The stanza is crowned with the colon-ed announcement:
"boy, 6 lbs.13 oz." the survivor, the transcender, alluding
to the music, which is all that can transcend in the line
"orchestrate and blow up your lungs," the orchestral infer-
ence of music, the blow like what Coltrane does, that sign
of survivor's life.

The child is born and breathes and the poem takes its
own breath and continues:

As you breathe easily, your mother's
mother is tubed and strapped
hemorrhaging slowly from her varices;
your two dead brothers who could
not breathe are berries
gone to rot at our table:
what is birth but death
with complexity: blood, veins,
machinery and love: our names.

Harper's poetics understand something about pinnacle
and crescendo, like the Coltrane of "A Love Supreme,"
having achieved something of the body and beyond it,

both essential and quintessential. "Love Song: Patrice Cuchulain" moves toward the lyric transcendence and resolution of its end with its conspicuous end-rhymed couplet. Rhyming "names" with "veins" brings us back to the composite parts of the body that add up and logically bring us to names, and not just the name of one but names plural: the son and his parents, the son and his "two dead brothers" and dying grandmother, the family and America. The child's name, as the title of the poem, is also a "medley" or melding of traditions. And the title of the poem, the boy's name, "Patrice Cuchulain," an unmistakable allusion to the martyred Congolese hero Patrice Lumumba who represented African independence writ large and symbolic across the African diaspora, especially to Civil Rights/Black Power America, and the Irish hero Cuchulain that Yeats gave us as poetry. But Harper does not theorize creolization, per se; rather, the power of his poetics resides in an unmasking of the always-already of American culture, mixed every which way.

"Nightmare Begins Responsibility" completes this poetic cycle with another crescendo:

> and of my distrusting self
> *white-doctor-who-breathed-for-him-all-night*
> say it for two sons gone,
> say nightmare, say it loud
> panebreaking heartmadness:
> nightmare begins responsibility.

What this Black Power–era poet wants a reader to "say it loud" is about blackness and about pride, certainly, but

from an angle of profoundest intimacy, as though nothing is worth saying loudly unless it is felt from a place as deep as this. When I first read Harper as an undergraduate student it was with the late professor Michael Cooke, who thought about Harper's work in terms of its striving toward intimacy and "kinship" as the only way of transcending racial injustice and intra-community conflict.[38] Harper asks a reader to:

> Ponder the spent name of Jonathan,
> apple and brother in the next
> world, where the sacred text
> of survival is buried in the bosom
> of a child, radiated
> in moonlight forever.

Harper writes specifically about a black man (his brother) and black men-to-be (his sons) who did not survive in turbulent racial times, whose deaths will always be set like stone in time and place. It is loss of masculine promise that he mourns, and this is in some ways consonant with a masculinist approach to heroism and nation-building and -imagining among even some of the women in the Black Arts Movement. But Harper takes us to a white mother's grief and then to the poet's own grief. He continually calls for his emblematic term "debridement," that excruciating scraping of skin that is necessary to heal and the move to articulate "great pain" and then see where it takes us, what it tells us, where it sends us.

4. BLACK CRYPTOGRAM

"I began to write poems because I could not see those elements of my life that I considered sacred reflected in my course of study: scientific, linguistic, and literary," Harper writes in his notes to *Songlines in Michaeltree*. These notes give us a clear sense of the overall animating project of his work. As discussed above in the context of Harper's poetic relationship to Coltrane, in one way, *Songlines in Michaeltree* is like one long poem, in the way that Harper returns to so many of the same motifs and themes but reworks them. "Double conscious brother in the veil," for example, is repeated until he works it out, works it through, until he himself understands it. It is a blues repetition: say something over and over to make it collective, to make it multiply, to make an "I" become a community, to make a single unit of language be part of a field or forest of language. We revisit apple tree, uterus, two dead sons, twitch, Hudson, America, "history as:," "the Johnson lungs," "the library I should have had," to name just a few. *Songlines* has a recurring cast of characters: Frederick Douglass, W. E. B. Du Bois, W. H. Auden, Christopher Isherwood, Sterling Brown (over and over), Robert Hayden, Gwendolyn Brooks (over and over), Seamus Heaney, Romare Bearden. He tells many of the same stories from poem to poem but at a slightly different angle. A dog attendant at the poet's birth in one poem becomes specified as "Trigger, the Pekingese" in another. A birthmark mole in one poem is watched for change in the poet's sixtieth year and teaches "love your blemishes" in another. Many of these repetitions create

the effect of the process of remembering, returning to motifs in hope that some shard of memory and thus insight will jog loose.

This is not to say that the work does not change formally. For example, Harper has become quite fond of the two-line stanza in both short and long units of measure; its tension and delicacy suits his often-epigrammatic voice well. And the photographs that so interest him early on become something intriguingly called "psychophotos" in later work, to offer another example of his ongoing evolution. Like a great jazz musician over a career, his voice changes but is always identifiable.

The notes at the end of the book are extraordinarily rich, and Harper has done his readers a generous service by giving the deep historical and contextual background of so many of these allusive poems. While one cannot read poetry solely by the light of the poet's lantern, what a poet has to say about his or her own work is nonetheless instructive. Harper gives us something of a Rosetta stone for some of the more imbedded recurrent references in an afterword "To the Reader." He parses, for example, the oft-mentioned "Johnson lungs" and introduces the reader to his maternal great-grandfather John Albert Johnson, "a Canadian-educated prelate whose Bermuda journal, 1888–92, was the first written account of the daily life of a missionary. One of his first entries was about the ending of slavery in Brazil (1888) and his questioning of the monarchy as "a colonial assumption of control and progress." As an AME bishop, Johnson spent eight years

(1908–1916) in South Africa, which gives context to the poems set there.

What is a "Michaeltree," anyway? Harper tells us it is the affectionate name bestowed upon him by his godson, Rafael Stepto, that for the poet "became a filter to a magical conceit." It speaks grandly to this work, where "trees" are motifs that enable the poet to ask questions of self and the larger community, African American and American. Where are we rooted? How have we branched? What is the human body's relationship to the earth, and to the nation? How do we veer and intersect as we expand? How do we shelter? How can poetry do any of this? How does the whole integrate and heal its diseased limbs or members; yes, how do we each, alone and together, heal?

5. THIS SCENE IS ABOUT POWER

When Harper invokes violence, it is not theoretical or rhetorical (as in Nikki Giovanni's "Nigger can you kill") but real, as real as the previously cited "sex, fingers, toes / in the marketplace / near your father's church / in Hamlet, North Carolina," black male body parts for sale after a lynching in full view of God's house. When he writes, "America needs a killing / America needs a killing / Survivors will be human," we might be startled by his call. I thought about "survivors will be human," and it first seemed to me that the human-ness of survivors was a coming together or reaching out in search of empathy. But human survivors can be bitter, vindictive, and broken. I think Harper's poetry exemplifies the ongoing legacy

of brutality and human survival. He considers in a poem the story of a letter Du Bois receives from a student: "The class is confronted / with a question, / and no one—/ not even the professor—/ is sure of the answer: / "Will you please tell us / whether or not it is true / that negroes / are not able to cry." That the professor is not sure of the answer brings a powerful wondering into the poem. Is the father in the poem who has lost two sons so wearied by that grief that he, too, cannot cry, or, more richly, does he not know if he can or could?

Harper is productively obsessed with WITNESS. Even the dead baby witnesses in the way that witness is often symbolic, standing for all that is "rot" and "decay" in America, in a family, in the unfair algebra that parses suffering as it takes some children and lets others live. In this grammar of inequity, where and what is power— human, black—in these poems? Consider "Song: *I Want a Witness*":

> Blacks in frame houses
> call to the helicopters,
> their antlered arms
> spinning; jeeps pad
> these glass-studded streets;
> on this hill are tanks painted gold.
>
> Our children sing
> spirituals of *Motown,*
> idioms these streets suckled
> on a southern road.

This scene is about power,
terror, producing
love and pain and pathology;
in an army of white dust,
blacks here to *testify*
and *testify*, and *testify*,
and *redeem*, and *redeem*,
in black smoke coming,
as they wave their arms,
as they wave their tongues.

The mention of "blacks," "jeeps," "helicopters," "and "tanks" suggests late-sixties race riots, and the "frame houses" and "hill" suggest the Los Angeles known to the poet, presumably the Watts riots. There is wild hope in riot, but the poem reminds us, with "glass-studded streets; / on this hill are tanks painted gold," of the false promise of capital and of violence as well, the glitter that deceives.

Harper thinks in communal terms in this poem when he says "*Our* children," and in the new day the Negro spirituals have become "spirituals of *Motown*," as a people always rework and update its talismans and guideposts. Then he changes the poem's mode of address to directly declare, "This scene is about power." The word "power" cannot help but invoke Black Power, given the street scene it describes, but then it is immediately followed, after a line break, with "terror"; not only the terror that protest created in some spectators but perhaps a window into the terror of those who struggle to decide how to act in the face of injustice. The struggle begets not only

"love and pain" but also "pathology," which, it seems, the poem is literally acting to transcend. "[A]n army of white dust"—the forces that come to discipline during race riots—moves to "in black smoke coming," a black human power that at this point in the poem is still ephemeral, though envisioned.

But then the poem makes its great shift, and revelation. The italics on "testify" and "redeem" render them quoted speech, bringing the literal voice of the collected "blacks" into the body of the poem as Coltrane's transcendent voice has been brought into other works. This is ideologically compelling: the idea that the poet, singular, is bringing the voices of the many into the poem, which becomes a chant. When you say "a love supreme" often enough it becomes chant. It takes residence in the body. And I think Coltrane or Harper might assert that it becomes a speech act. It performs itself. Thus the poem enacts not merely "love supreme" but the specific "a love supreme," one human voice speaking: testimony.

"As they wave their arms": wave for help, wave to say something, for the body to speak. "As they wave their tongues," not wag their tongues, not an idle act of mere greeting. Waving tongues, speaking in tongues, speaking strange truth through chaos. This poem is printed twice in the 1972 volume that bears its name, as "Foreword" and "Afterword," the beginning and the end, the frame, the most important thing the book has to say, the light by which we read the book and the final taste on our tongues.

To return to the poem's most striking moment, the

thrice-repeated "testify," italicized for emphasis, takes us back to the word's root. The word tries, as the "antlered arms / spinning" to take off into flight into meaning and resonance, significance: repetition that tries to make sense out of injustice and song out of witness. Its repetition makes us consider the word again and again, the word and its power, and the power of a poetry that testifies thus.

And it is testimony, or, the text itself, that takes us inside the black interior, a moment, a movement. "The sixties" has become an iconic time in memory, and we think we know what we mean when we say "Black Power." But a careful look at the texts and testimony of the time (as any) reveals various black powers more richly nuanced and textured than glib summaries represent. Who we leave in and out of our political canons has a great deal to do with how we call the young forces of the present to the task of productive political and culture-work. Harper's example is a call for a look to the insides of archives and bodies of work themselves in their original contexts, not just as we receive them in anthologies that operate with the hard-to-avoid periodizing, tidying-up impulses of the presents in which they are made.

My fantasy is to put many of the writers from this era (including some of the dead ones—it is a fantasy, after all) on a stage to talk together about those important years we call "the sixties" and tell us who was saying what to whom off the record, who was aligned with whom, what were the goals that we might now understand as shared even if the means differed. I don't yearn for reconciliation per se so much as a more accurate record to understand the

actors and their aims, and the times, and therefore how we might face today's challenges accompanied by real insights from the past. Testify: to make yourself a witness, here through the old-fashioned means of storytelling, close reading, and literary reconstruction.

THE WORLD ACCORDING TO *JET,*
OR,
NOTES TOWARD A NOTION
OF RACE-PRIDE

◆

On Richard Pryor's brilliant, short-lived 1977 television show, Pryor played the first black president of the United States holding his first press conference. He calls on reporters and one at a time they identify themselves and their affiliations. A tall, dead-serious black woman (played by Marsha Warfield) stands imperiously and says, slowly, "Roberta Davies," comma, "*JET* magazine." Period. And the first black president of the United States salutes.

Do I need to tell the uninitiated what *Jet* is? Since 1951, only black America's national organ, a little lozenge of a magazine that could fit in the palm of your hand or hip pocket. *Jet* was created by black mega-publisher John H. Johnson, who also produced the now-defunct *Negro Digest/Black World,* as well as the hardy perennial *Ebony. Jet* is a newsmagazine, a gossip rag, a grapevine, a trumpet. It is still published weekly and is, in short, what Charlayne Hunter-Gault and so many others have called "Black America's weekly news bible."

Or was. In the current period in which black-oriented, magazines like *Savoy, Essence, Black Issues Book Review,* and *Vibe* are readily available in the mass market, *Jet* seems a little, well, outdated. Not only is it graphically faithful to its early incarnations, it speaks from a perspective that is best described as old-fashioned race-pride.

I lived for some years in Chicago, home of Johnson Publications, and that led me to ruminate on the modern-day permutations of that old-fashioned race-pride. Race-pride of a particular order is characteristically *Jet,* and *Jet* is quintessential black Chicago, as I observed it there: brash, buy-black, bluesy, bottom-line. Only black people would call the bitter, chronic lake wind by name, and only the toughest of those could survive the mighty Hawk. In Chicago, I feel I am in the heart of a true Negro metropolis.

Jet's current format is remarkably faithful to the way it started out. Sections include "National Report," "Ticker Tape U.S.A.," which has always been written by Simeon Booker. Names are printed in boldface and there are abundant photographs; the very graphics of the magazine say that black people are important, worth shouting about and looking at with pride. Those photos also say that black people who appear on the pages of *Jet* were important and as such the magazine became an arbiter of black America, a namer of its movers, shakers, jelly-makers.

"Weekly Almanac" contains one-paragraph stories of the black and bizarre. A recent story titled "Pork Chop" told of a high-school agriculture teacher who was fired "after one of his students castrated a pig by biting the

animal's testicles in class." "Cracker Giveaway" notes that the British government plans to give away thousands of tons of crackers, some of which are forty years old, that the country had stockpiled in case of war. In "Pretty Believable," a Jonestown, Pennsylvania, judge releases without bail a nineteen-year-old woman charged with forgery, "saying it would be a shame to see such a 'pretty' woman in jail."

The "People" section chronicles the one-line professional accomplishments of the black middle class, and "Society World," with its subheading, "Cocktail Chit-Chat," chronicles their parties. "Inventions by Blacks that Make Life Better for All" was a recent feature of "This Week in Black History." "The Week's Best Photos" still has that *Jet* hallmark: the "Beauty of the Week." She isn't quite naked, but she's often wearing a string bikini and is quoted on her favorite hobbies, which usually include aerobics and modeling. In recent years, many of these photographs have been taken by Lamont McLemore, who I think must be the same Lamont McLemore of the defunct, tall and tan singing group, the Fifth Dimension. This would be very *Jet*, which is heavy on celebrities of these bygone days. McLemore stands for both black respectability (they were so *clean*, so un-gut-bucket) and for blacks rescued from obscurity.

To this day *Jet* runs television listings in the back where you can find out where and when black people will be on television. The listings are now somewhat abridged, but they are a reminder of the times when all black appearances on television in a week could fit on one small page. All you have to be is black and on TV to be worthy

of this section. An article on Robert Fogel, a Nobel Prize winner for Economics and a white man, quickly became an article about the accomplishments of his wife, Enid, who is black. (Or, as *Jet* would write, "who is Black.") If there's black in it, anywhere, *Jet* finds it.

I first read *Jet* before I could read. My grandfather kept *Jet* magazines on a rack on the back of the door of the room where I slept when I visited his Harlem apartment. His archive went from the 1950s forward, and these issues were my favorite things to look at when I was there. I grew up in a home and in an era where integration was the gospel and I was part of the great experiment. Most of my schoolmates were white; *Jet* fascinated me because it spoke unabashedly for a black nation in a time when Martin Luther King Jr. was talking about holding hands and singing that old Negro spiritual. Since I was, metaphorically and by inference, one of those black children holding hands and singing with the white children, *Jet* seemed to me to sound black notes from the lower frequencies, saying go ahead, hold hands, but know who your people are, and know that it means something crucial—though who could say precisely what—to be of a people. Before I understood the profound difficulties of the enterprise of integration, that low rumble of race-pride was sneaking its way into my subconscious, to the part driven by compulsion, the part that yearned for the world according to *Jet*.

My whole family, present and past, has helped me understand this thing called race-pride: your own progress was intricately tied to the progress of your people. In the old-fashioned sense, the good works of the part

reflected on the whole. Of course, the benefits don't always trickle down, and black communities are often stratified by class. But when I was a teenager, someone shot a bullet through the window of our home in Connecticut, and my grandfather unhesitatingly attributed it to "race-hate." Maybe it was, maybe it wasn't, but his was a deeply educated guess, given that we were the only black family in that particular neighborhood at the time; my father has done "race-work" of some note over the years, and the United States is not unknown for those sorts of crimes. What impressed me most was the speed and conviction with which my grandfather pronounced his verdict: "race-hate." *Jet* is somehow a handbook for a logic that understands the primacy of race, the primacy of blackness; *Jet* understands the way in which some situations are reducible to and explicable by race and the way in which such formulations are not simplistic. This was important for me to understand as I grew up in an era in which the happy rhetoric of integration was gospel.

Before I went back and looked at actual copies of the magazine, I thought about *Jet*'s legacy to me, what I remembered. It was the freaks, freaks whose stories were in *Jet*'s pages merely because they were freaks and black. There were the gospel-singing Siamese twins Yvonne and Yvette McCarther who made regular appearances in *Jet* over the years, until they died. They were joined at the head, their two bodies forming a single arch. Then there was the quadriplegic woman who diapered her baby with her teeth and tongue, and the pre-Bobbitt black boy whose penis was accidentally cut off in a kitchen mishap, went down the drain, and was retrieved by a black

fireman and successfully reattached. *Jet* kept vigil week after week while Jackie Wilson languished in a coma by giving more details than some might have liked but never enough for prurient me. Before there was *People* or the *National Enquirer,* there was *Jet.* I imagine that those magazines to an extent patterned themselves after *Jet.*

There is something touching to me about the way in which *Jet* has been the caretaker of the curious tales of black life. Where else would you read about the Siamese twins? *Jet* was where I followed the story of Joan Little, the black woman in prison who stabbed her white guard to death with an ice pick when he tried to rape her. And *Jet* is where maligned black America has often pled its case. Frank Willis, the black guard who discovered the telltale tape on the door of the Democratic National Committee headquarters in Watergate and began the chain of events that brought down a corrupt presidency, was found to be unemployed, living with his mother, and accused of stealing a twelve-dollar pair of sneakers. In a *Jet* "exclusive," he said it was "a total mix-up," which is all the magazine's prototypical readership would need to know since black is always right in *Jet.*

Why would anyone want to know these stories anymore, you might ask, but in this young millennium there is still something potent about a magazine that says, Your life is important because it is black. You exist, in the way that some black turn-of-the-century anthologies busily chronicled the noteworthy doings of black undertakers, dentists, and the like. In some ways *Jet* is more populist, even as it unabashedly celebrates material gain and self-promotes the Johnson family (Eunice Johnson smiles

with a cavalcade of sepia beauties week after week at the Ebony-Fashion Fair) as a prototype for its patriarchal vision of the black American family, following the benevolent Dad to the promised land. John Johnson is in many ways a modern-day Booker T. Washington, and Washingtonian judgments about black uplift permeate the pages.

What does this particular variety of race-thinking mean today? Are the fates of black people intertwined in a way that speaks for the need for a magazine that purports to speak to an entire black nation? There is something romantic and appealing about the ideas that black people are somehow discernibly connected across the country and the diaspora. But common sense says otherwise; indeed, the monolithic phrase, "the black community," has rightly come to seem imprecise. There have always been class differences among black people, differences of aim, aspiration, and opportunity. How, then, to work with the romantic impulse for community, for racial collectivity, while at the same time bringing an open-eyed understanding of these differences to such racialistic imaginings? And when the Johnsonian model of race-pride puts the all-knowing father at the head of the family, what do we do with race when everyone involved is black, when it's Clarence versus Anita or Desiree versus Mike? I want to trash the centerfold and hold onto Joan Little, claim the importance of visibility and extend that in *Jet's* pages to other strong, unruly women, gays, and lesbians.

In 1955 when fourteen-year-old Emmett Till was lynched in Money, Mississippi, *Jet* published the photograph of his bloated, ruined body that would burn itself

into the minds of black America. *Jet* told the story Americans needed to know. We are past the legal gains of the Civil Rights era, but we still haven't "overcome" and are not even sure we're a "we." My problems with *Jet* are myriad, but I'm still a reader. With each instance in which the violation of a black person is made public in its pages, I am able to think about whether it is violence, or its ever-present possibility, that unites us as black people. And I still revel in straight-up celebration of black glory. However tacky, however ephemeral those photos of black celebrities outside of Ebony-Jet headquarters may be, I still hold onto them as to an idea that this thing called black culture and these people called black people can both be productively, complexly understood as nuanced entities whose acts and practices we hold to the challenge of criticism.

ANNA JULIA COOPER:
TURN-OF-THE-CENTURY
"AFRAMERICAN" INTELLECTUAL

•

In 1892, Washington, D.C., educator, Anna Julia Cooper, published *A Voice from the South*, her collection of essays considering questions of race, gender, education, and other topics. What Mary Helen Washington has called "the most precise, forceful, well-argued statement of black feminist thought to come out of the nineteenth century" was written in an Afro-America in a state of desperate flux.[39] Lynching, legal disfranchisement, and court-sanctioned segregation were in place and on the rise. By 1892, most of the major African American higher educational institutions—Howard, Tuskegee, Hampton, Fisk, and others—had been founded. The Fisk Jubilee Singers had traveled to Europe and raised $150,000, much of which went to further construction of the university, and T. Thomas Fortune had founded the self-help-oriented African-American League. The General Federation of Women's Clubs, which expressly excluded African American women, was established in 1890. Four million women participated in the 1890 American work-force, one million of whom were African American. This

was the age of reform in the post–Civil War United States; by the end of the decade, American imperialism would be the order of the day.

The depression of 1893 and *Plessy v. Ferguson* (1896) were just ahead. The year 1892 was one of intense contradictions for the woman activists of the emergent African American elite. In 1892, when lynching was at its highest point, the black women's club movement—led at that point by Josephine St. Pierre Ruffin, Susan McKinney, and Victoria Earle Matthews—was born. Frances Ellen Watkins Harper's novel, *Iola Leroy; or, Shadows Uplifted;* Ida B. Wells's *Southern Horrors: Lynch Law in All Its Phases* and *Oak and Ivy;* and Paul Laurence Dunbar's first book of poems were each published or at press. Booker T. Washington was nine years away from publishing *Up from Slavery.* W. E. B. Du Bois was a graduate student at Friedrich Wilhelm University in Berlin with *The Souls of Black Folk* eleven years ahead.

This is but a thumbnail sketch of the climate in which Cooper wrote *A Voice from the South,* essays written between 1886 and 1892, which primarily consider questions of race and gender, separately and as they intersect.[40] Cooper critiques the burgeoning white women's movement for its racist exclusions as well as African American male "race-leaders" for their neglect of both the potential and actual contributions of women. "While our men seem thoroughly abreast of the times on almost every other subject," she wrote, "when they strike the woman question they drop back into sixteenth-century logic." She examines images of African peoples in literature by

white writers and critiques the ethics behind burgeoning U.S. expansionism. Cooper viewed the arenas of politics and culture, from the grass roots to the elite echelons, as realms that needed to hear African American women's voices in order to survive. This sentiment was not uncommon for similarly well-educated, activist African American women of the time, for whom "Lifting As We Climb," the motto of the National Association of Colored Women, would become a credo.

Looking at *A Voice* as a whole, rather than at its parts, reveals a textual strategy taken by Cooper to find a new form in which to house the contemplations of an African American female intellectual, and, by extension, a nascent African American women's intellectual movement.[41] The essays are at once allegory, autobiography, history, oratory, poetry, and literary criticism, with traces of other forms of address. Only such a diverse structure could encompass the tensions of forging an African American, female, demonstrably thinking self from whatever intellectual material was at hand. Additionally, Cooper's strategic use of the first-person "I" reveals the ways in which she allows her own experience—her own existence, even—to inform the rhetoric of her text as evidence for the feminist strategy she advocates. By metaphorically writing her body into the book, Cooper forges textual space for the creation of the turn-of-the-century African American female intellectual. *A Voice* becomes a symbolic representation of the body of the African American woman of letters, newly created in the public sphere.

While Cooper uses much of the same language and

knowledge as both her intellectual "fathers" (white) and "brothers" (African American), she injects her forceful arguments with personal anecdotes. Each of the essays moves in and out of the first person, thus fusing a received notion of political theory with the particulars of an African American and female life. These essays stand in a new space between the first-person confessional of the slave narrative or spiritual autobiography and the third-person imperative of political essays. In *A Voice*, Cooper creates an unprecedented self: the African American female intellectual at the end of the nineteenth century, barely a generation beyond slavery (she was born a slave) and two generations before the unimaginable changes to come.

I first came to Cooper's words almost one hundred years after she wrote them, at another important historical juncture for black feminists in the United States. I knew she was just the fourth African American woman to earn a Ph.D. in the relatively recent year of 1925; I would soon earn mine. I worked around that time with the Chicago branch of the group "African-American Women in Defense of Ourselves," trying to craft and enact responses in various media to the ongoing defamation of black women marked historically by Anita Hill's treatment during the Clarence Thomas confirmation hearing. This moment in the 1990s galvanized especially black women in academia to come together collectively and be articulate and proactive about the issues facing black women across boundaries as the new millennium approached.

Cooper's words felt urgent and fresh to me then and were an important reminder that we needed to be ever vigilant about claiming and maintaining the work of our foremothers, and learning from their examples and courage. But it was also her formal innovation that meant the world to me as I tried to make my way through what sometimes felt like the minefields of academia. How could I "write theory" in a voice that was truly mine? Why, in academic exercises, did I frequently feel that so much of my knowing was inaccessible to me? Yet why did I also not feel comfortable writing in the "womanist" mode of Alice Walker in "In Search of Our Mother's Gardens"? I admired the intellectual example of this essay tremendously, but Alice Walker's experience—as fiction writer, mother, daughter of the South, worker in the Civil Rights movement—was not mine. While Walker's way of thinking on paper excited me, it didn't offer a model for how to write the various aspects of my self into critical prose.

In *The Alchemy of Race and Rights: The Diary of a Law Professor,* Patricia J. Williams describes how she hopes her life's mission and vision can be manifest in her written work, and this opened a window into Cooper, and my own work:

> [I am] trying to challenge the usual limits of commercial discourse by using an intentionally double-voiced and relational, rather than a traditionally legal black-letter, vocabulary. For example, I am a commercial lawyer as well as a teacher of contract and property law. I am also black and female, a status that one of my

former employers described as being "at oxy-moronic odds" with that of commercial lawyer. While I certainly took issue with that particular characterization, it is true that my attempts to write in my own voice have placed me in the center of a snarl of social tensions and crossed boundaries. . . . I am trying to create a genre of legal writing to fill the gaps of traditional legal scholarship. . . . Thus . . . I hope that the gaps in my own writing will be self-consciously filled by the reader. . . . To this end, I exploit all sorts of literary devices, including parody, parable, and poetry.[42]

A lawyer (public) publishing a diary (private); an African American woman writing the law in which for so long she was misrepresented; these are the oxymoronic truths of African American women writing in the public spaces of theory at the dawn of a new century. And the phrase "at oxymoronic odds" helped me see that the oxymoronic is where the power is. Our literature—that is, the written literature of African American women—is rich and diverse, but it is not a body of work so vast that there is not a great deal of room for formal innovations that open up the way we see ourselves and record that which is unreconciled and perhaps unreconcilable inside us. That is sometimes a source of our great power. Cooper in 1892 exemplifies this power and innovation, and that is why her work has been so important to me in thinking about how to write my own version of the American essay.

The facts of Cooper's life are crucial to understanding both the historical context in which she wrote as well as how those biographical particulars inform *A Voice*. Cooper was born Anna Julia Haywood in Raleigh, North Carolina, in 1858, the daughter of Hannah Stanley Haywood, an African American woman who was a slave and "presumably," in Cooper's words, of George Washington Haywood, her mother's white master. Of her parents, Cooper writes:

> My mother was a slave and the finest woman I have ever known. Tho untutored she could read her Bible and write a little. It is one of my happiest childhood memories explaining for her the subtle differences between q's and g's or between b's and l's. Presumably my father was her master, if so I owe him not a sou & she was always too modest and shamefaced ever to mention him.[43]

In that same account, Cooper reveals an early sense of race collectivity and duty. She describes herself as a baby in the crib as the Civil War raged nearby. This construction is chronologically problematic—she would have grown beyond the crib by the time the war reached her region, and she was not, as she says, born "during" the war—but nonetheless provides an important blueprint for the ideas of self-situation developed in *A Voice:*

> I was born during the civil war and served many an anxious slave's superstition to wake the baby up and ask directly "Which side is goin' to win

de war?"; "Will de Yankees beat de Rebs + will
Linkum free de Niggers." I want to say that while
it may be true in infancy we are nearer Heaven,
if I had any vision or second sight in those days
that made my answers significant to the troubled
souls that hung breathless on my cryptic answers,
such powers promptly took their flight with the
dawn of intelligent consciousness.

In this passage she chooses to present herself as a prophet
of sorts chosen by "troubled" fellow slaves. In *A Voice*
Cooper professes great admiration for Harriet Beecher
Stowe's "power ... humility and love," and here she, like
Stowe, renders slaves as naïfs governed by "superstitions."
Cooper's tone here and in parts of *A Voice* with regard to
her relationship to those for whom she has chosen to lift
her voice may make today's readers uncomfortable. Yet
she both places herself squarely within the slave commu-
nity and acknowledges her own privileged status that at
times sets her apart in terms of knowledge and language.
Her narration here also illustrates the war Cooper will
fight in *A Voice* between intuition, or so-called women's
knowledge, and the "book learning" that in the nine-
teenth century was the legacy of men, white men specifi-
cally. She posits herself as having access, whether or not it
is exercised, to both intuition, the gift that "Heaven" has
bestowed on women and non-elite African Americans,
and "intelligent consciousness," the legacy earned by her
relentless pursuit of book learning and the subsequent
status it afforded her. This yoked notion of class privilege
and duty, even within a slave community, is an intrinsic

part of Cooper's vision of her life and work. In her own eyes, from that first moment in her cradle, she is someone with a message for the masses, however discomfiting that notion of her own position might be to her readers. Cooper also presents in more than one language, however crudely rendered (we will see others later in her work); she moves easily into her remembered slave dialect of those "troubled souls" at the same time that she is fluent in elegant standard written English. These presented aspects of herself are not necessarily contradictory; she simply writes complexity and multiplicity into her own situation. For Cooper, too, was a slave at this point; within the black bonded Cooper sees herself as separate from as well as part of them.

In 1868 Cooper attended the newly opened St. Augustine's Normal School and Collegiate Institute. The school was formed under the auspices of the Protestant Episcopal Church to serve newly freed slaves. A curious condition of admission, given the recent end of the war, was some prior academic training. We can infer from that as well as from Cooper's autobiographical account that Cooper's mother encouraged her daughter's education from a very young age. Cooper's account of her time at St. Augustine's in *A Voice* chronicles a struggle to reap the same educational benefits as her fellow male students. Cooper's personal papers reveal little more about her encounters with educational obstacles, but they do manifest, from her earliest articulation of her life's goals, a dogged desire akin to a bona fide calling to be an educator.[44]

In 1877 Annie Haywood married George Cooper, who was a candidate for the ministry at St. Augustine. He died

just two years later, and Anna Julia Cooper, in pursuit of
a career in teaching, wrote to Oberlin College request-
ing admission, tuition, and employment.[45] In one of her
letters requesting admission to the school, she wrote that
at St. Augustine's she had studied "beside the English
branches, Latin: Caesar; seven books; Virgil's Aeneid, six
books; Sallust's Cataline and Jugurtha; and a few ora-
tions of Cicero;—Greek: White's first lessons; Goodwin's
Greek Reader, containing selections from Xenophon,
Plato, Herodotus and Thucydides; and five or six books
of the Iliad;—Mathematics: Algebra and Geometry en-
tire." Cooper received her B.A. from Oberlin in the class
of 1884, which included two other African American
women, Mary Church (Terrell) and Ida Gibbs (Hunt).
Cooper then received an M.A. in mathematics from the
same college in 1887. She went on to be a teacher and
principal of the M Street High School, later to become
Dunbar High School, in Washington, D.C. In 1930 she
became the second president of Frelinghuysen University
also in Washington, a group of schools created to pro-
vide social services, religious training, and educational
programs to adult students who worked during the day.
The school for a time operated out of Cooper's home at
201 T Street N.W. Perhaps the highlight of Cooper's life
of scholarship and teaching came on 29 December 1925,
when, in a ceremony chaired by Alain Locke at Howard
University, Anna Julia Cooper was awarded a Ph.D. from
the Université de Paris (Sorbonne). Her dissertation on
attitudes toward slavery in France between 1789 and 1848
was written in French. She was sixty-seven years old and
the fourth African American woman to earn a Ph.D.

This extensive discussion of Cooper's life is important because of the ways in which these very facts, up to 1892, are utilized in *A Voice*. Like her contemporaries and many African American writers who would follow, Cooper wrote out of the impulse to present a unified, serviceable vision of a future for African Americans as well as out of a simultaneous resistance to a static, monolithic view of what it was to be black, and, specifically, to be a black woman. Attacking racial stereotypes was an important part of Cooper's written agenda, though some of her own arguments about male and female "nature" were extremely essentialist.

Cooper's continual commitment to educating others who had not received her elite education is a key element in *A Voice* and in her life. The fervor of that commitment also illuminates some of the class politics and issues in her life and work. Cooper saw herself and her peers as a class apart in the sense that they felt bound to "uplift" the "masses," but also as inextricably of and devoted to her fellow African Americans. Was Cooper's tone condescending or was it pragmatic, given the realities of who was able to be educated in those post-slavery years and the hopes of many African Americans for what education might bring? This attitude was famously articulated several years later in W. E. B. Du Bois's 1903 article "The Talented Tenth," in which he wrote:

> Men of America, the problem is plain before
> you. Here is a race transplanted through the
> criminal foolishness of your fathers. Whether
> you like it or not the millions are here, and here

they will remain. If you do not lift them up, they
will pull you down. Education and work are the
levers to uplift a people. Work alone will not do
it unless inspired by the right ideals and guided
by intelligence. Education must not simply
teach work—it must teach Life. The Talented
Tenth of the Negro race must be made leaders of
thought and missionaries of culture among their
people. No others can do this work and Negro
colleges must train men for it. The Negro race,
like all other races, is going to be saved by its
exceptional men.[46]

Du Bois, like Cooper, is alternately inspiring and conde-
scending in the essay. He is also in specific debate with
Booker T. Washington's more "pragmatic" approach to
training African Americans. Cooper's zeal for education
veers into something more interesting, complex, and ul-
timately perhaps more discomfiting than noblesse oblige.
I would say her righteous fervor was born of the urgency
of her times and the situation of her race that, while it
made her veer at times into condescending language and
thought, nonetheless has its own logic and integrity.

Producing books had powerful significance for African
Americans at this point in history, as Henry Louis Gates
Jr. explains: "Deprived of formal recognition of their
subjectivity in Western arts and letters, in jurisprudence,
and in all that signals full citizenship, African Americans
sought the permanence of the book to write their rhe-
torical selves into language. I write therefore I am."[47] In
Writing a Woman's Life, Carolyn Heilbrun posits a similar

theory about why women write. She describes why she began to write detective novels:

> I believe now that I must have wanted, with extraordinary fervor, to create a space for myself. This was, physically, almost impossible.... If there was no space for a woman in the suburban dream house, how unlikely that there would be space in a small city apartment. So I sought, I now guess, psychic space. But I also sought another identity, another role. I sought to create an individual whose destiny offered more possibility than I could comfortably imagine for myself.[48]

For the purposes of considering the autobiographical element in Cooper's essays and exploring the personal stake involved her philosophy, Heilbrun's comments are helpful. She points out that writing in genres not identifiably autobiographical nonetheless can bear autobiographical impulses. Cooper writes *A Voice* at an exquisite moment in history and with great self-consciousness:

> The race is just twenty-one years removed from the conception and experience of a chattel, just at the age of ruddy manhood [sic]. It is well enough to pause a moment for retrospection, introspection, and prospection. We look back, not to become inflated with conceit because of the depths from which we have arisen, but that we may learn wisdom from experience. We look within that we may gather together once more our forces, and, by improved and more practical methods, address

> ourselves to the tasks before us. . . . But this survey
> of the failures or achievements of the past, the dif-
> ficulties and embarrassments of the present, and
> the mingled hopes and fears for the future, must
> not degenerate into mere dreaming nor consume
> the time which belongs to the practical and effec-
> tive handling of the crucial questions of the hour;
> and there can be no issue more vital and momen-
> tous than this of the womanhood of the race.

"Experience" is crucial, in Cooper's view, to the theoriza-
tion of a race- and gender-based critique of America. As
Hazel Carby has pointed out, the challenges faced by
African American women seeking expression in either
spoken or written realms are dual: "In order to gain a
public voice as orators or published writers, black women
had to confront the dominant domestic ideologies and
literary conventions of womanhood which excluded
them from the definition 'woman.'"[49]

Any African American tradition begins against that
backdrop as well as against a long history of denied literacy
in which the legally forbidden word represented a kind of
freedom. It was necessary, then, for the African American
writer to construct an autobiographical stance that would
say "I am here" in a hostile environment. The "I am here"
occurs simultaneously with "Who I am" as the critic defines
him- or herself in relationship to the cultural condition he
or she sees and describes. Autobiography, then, as Valerie
Smith usefully puts it, is "process, rather than genre," a
mode of thinking and therefore a theory of reading as well.[50]

—

In a key section of *A Voice from the South*, Anna Julia Cooper describes traveling through "a land over which floated the Union Jack," testing her hypothesis that "there can be no true test of national courtesy without travel." She arrives at a run-down railroad station and looks toward the bathrooms: "I see two dingy little rooms with 'FOR LADIES' swinging over one and 'FOR COLORED PEOPLE' over the other; while wondering under which head I come." Where does Cooper's body, both a "lady" (encompassing gender and class), and "colored" (encompassing race and humanity), belong? She is resistant to the direct challenge presented here. How can she exist in this physical space? To choose either door erases some crucial part of her identity, yet to embrace both and act upon them renders her literally impossible in her time and space. Pointing to the injustice of no-space for the African American female body, Cooper mutters, "under my breath, 'What a field for the missionary woman.'" She is that missionary woman, facing the challenges to self-definition that mark the most intimate aspects of her daily life.

Cooper does not tell us what happens next; the story's strength is rhetorical. But this episode poses the most fundamental questions of selfhood and the resistance to misdefinition by exploring public spaces in which the black woman can exist and speak. It also suggests a possible answer as to why region—rather than race, gender, or other aspects that shape identity—is emphasized in Cooper's title, *A Voice from the South*. Cooper places herself squarely in North Carolina and Washington, D.C., becoming an integral part of the history of the U.S. South,

a voice to be heeded as any other. Perhaps there is an unambiguous, physical certainty to terrain, unambiguous because as such it has meaning to white America as well. Perhaps also an invocation of region elides class distinctions between African Americans, positing the South as an equalizing master-text for black experience.

Anna Julia Cooper posits an African American woman's lived experience as evidentiary, just like the written words of the many white male writers with whom she engages in *A Voice*. She accomplishes this in two ways: first, by a continual marking of the oratory of the text with phrases such as "I confess" and "I would beg." Other first-person phrases with which Cooper opens paragraphs and statements include: "I see not why," "We must confess," "I do not imagine," "So far as I am informed," "Now I would ask in all earnestness," "Now please understand me," "All I claim," and "I grant you." Second, she opens many paragraphs with rhetorical questions and acknowledges an imagined opponent's responses. The first-person responses are particularly interesting because of how they refer to the physical presence of Cooper herself as speaker. They are self-effacing and might thus cleverly disarm her detractors. These moments offer a critical clue that Cooper saw her audience as made up of African American women like herself. She reminds her readers that they are in the process of being persuaded, and, in fact, that these essays were delivered orally, both before and after publication of the book.

Cooper places herself as an active, visible agent in the writing of the book. She liberally uses the first person and temporalizes her words throughout the text. For instance,

she will say "a few weeks ago" before an illustrative anec-
dote. This creates a sense of process in the narrative, of
someone in the midst of living her life and recording her
reactions to it. Cooper manifests "the black woman intel-
lectual." For example, she writes: "My readers will pardon
my illustrating my point and also giving a reason for the
fear that is in me, by a little bit of personal experience."
She claims that she is presenting "a simple unvarnished
photograph," although clearly choices and omissions are
at play in any autobiographical statement. Still, Cooper
says that what she gives a reader is "a little bit of personal
experience" to illuminate larger truths.

Cooper reminds her readers frequently that she lives
and moves within a physical body with sensations and
needs. This biological self-naming is a powerful weapon
in her arguments for racial equality. "When I seek food in
a public café or apply for first-class accommodations on
a railway train," she writes, " I do so because my physical
necessities are identical with those of other human be-
ings of like constitution and temperament." The "I" is a
physical "I." She has once again classified herself; in this
passage her upper-class (black) status is encoded in her
physical self.

Cooper has chosen as her governing metaphor the
corporeally situated image of the unheard voice of the
African American woman. What is more important than
what the African American woman is saying is that she
is speaking in the public sphere and must be heard. Using
the voice is a physical act, one that first announces the ex-
istence of the body of residence and then trumpets its ar-
rival in a public space. The spoken quality of Cooper's text

is crucial to understanding her own narrative strategizing, as the essays in *A Voice* were originally given as speeches. Chapter 1, for example, "Womanhood, a Vital Element in the Regeneration and Progress of a Race," was presented to a convocation of "colored clergy" of the Protestant Episcopal Church in Washington, D.C., in 1886. She would have presented this to an audience, then made up of all African American men. The African American female body is thus a concurrently speaking and thinking body that remains intact even when consciousness appears fragmented, such as the potentially fractious moment for Cooper at the train-station rest room.

The preface to *A Voice,* in which Cooper sets forth "Our Raison d'Être," offers the most extensive exploration of the metaphor of the voice as a blueprint for the rest of the book. She begins:

> In the clash and clatter of our American Conflict, it has been said that the South remains Silent. Like the Sphinx she inspires vociferous disputation, but herself takes little part in the noisy controversy. One muffled strain in the Silent South, a jarring chord and a vague and uncomprehended cadenza has been and still is the Negro. And of that muffled chord, the one mute and voiceless note has been the sadly expectant Black Woman,
>
> > An infant crying in the night,
> > An infant crying for the light;
> > And with *no language—but a cry.*

Cooper distinguishes between an actual voice and "clash and clatter," "vociferous," and "noise." A "cry" is differ-

ent from "language"; it is not mere sound or singing but rather meaning yoked to the physical presence of the voice itself. Therefore, it is not sufficient for Cooper simply to mark a space with sound but, rather, with sound in a certain, intelligible fashion, as we see her striving to do throughout the text.

Cooper frequently uses corporeal metaphors when discussing the experience of learning; even the intellectual life is experienced in physical terms. Take, for instance, when she describes the world of thinking men who have failed to incorporate (literally and metaphorically) women's perspectives: "The world has had to limp along with the wobbling gait and one-sided hesitancy of a man with one eye. Suddenly the bandage is removed from the other eye and the whole body is filled with light. It sees a circle where before it saw a segment. The darkened eye restores, every member rejoices with it." The part once again stands in for the whole. The eye is the key member on which the overall health and completion of the body hinges, just as Cooper and her ilk stand in for the whole of African American struggle. The refusal to see the body as divisible, head from heart or intellect from physicality, is further expounded when she sarcastically imagines, "What a travesty of its case for this eye to become plaintiff in a suit, *Eye vs. Foot.*" She then makes her analysis even clearer: "Why should woman become plaintiff in a suit versus the Indian, or the Negro or any other race or class who have been crushed under the iron heel of Anglo-Saxon power and selfishness?" The metaphor of the body works well to describe the divide-and-conquer strategy of white patriarchal dominion. This essay was presented

in Chicago in 1893 at a gathering of African American intellectuals protesting their exclusion at the Columbian Exposition. Women's perspectives are literally incorporated; the body without them is incomplete.

When she tells the story of the African American sculptor Edmonia Lewis, whom she describes as "my friend," she does so to illustrate how despite talent and training African American women's bodies are still kept out of the halls of learning for which some so desperately yearn. Lewis sent an application for admission to the Corcoran School of Art in Washington, D.C. The application was evaluated, "pronounced excellent," and Lewis was admitted. When Lewis showed up in that selfsame black and female body, *"in propria persona,"* as Cooper puts it, all promises were revoked. The school superintendent then "told her in plain unartistic English that of course he had not dreamed a colored person could do such work, and had he suspected the truth he would never have issued the ticket of admission." This is what Cooper herself is up against, and she knows that. Stories are told at a careful distance that separates her from the reality of her body long enough to make her way in the door. There is a constant tension between those distances; Cooper is giving these speeches to audiences that might not always have been sympathetic to her.

The use of sarcasm is another way that Cooper weaves more than one voice into the text. In arguing for higher education for women, Cooper in "her own" voice goes into a swiftly moving paragraph that runs from her own position to that which "men believed" about women's intelligence:

that higher education was incompatible with
the shape of the female cerebrum, and that even
if it could be acquired it must inevitably unsex
woman destroying the lisping, clinging, tenderly
helpless, and beautifully dependent creatures
whom men would so heroically think for and
so gallantly fight for, and giving in their stead a
formidable race of blue stockings with corkscrew
ringlets and other spinster propensities.

Again, it is the continual demonstration of her own "reason"—that she is capable of holding more than one thought and perspective in her mind at a given moment—that is at work in this passage. As much as this is wise and strategic, however, Cooper never abandons her own position; the passage is immediately followed by a one-line paragraph, "But these are eighteenth-century ideas," and is preceded by the pronouncement that exemplifies Cooperian philosophy at its most succinct: "We must be about our Father's business." She puts this phrase in quotation marks; she assumes her readers will know she cites Jesus speaking to his disciples in the Bible. But she also creates the effect of quoting herself at her most powerfully epigrammatic, making herself the authority on the subject at hand.

Cooper proves herself an expert at wielding the philosophy of the white fathers and African American brothers of literature and philosophy throughout the book. The presence, in her own adopted voice, of the counterattack on her own clearly stated position of advocacy of women's education shows Cooper as a product of multiple traditions

and points of view but nonetheless unified in her position. It "earns" her the rhetorical space—she was out to convince audiences, not merely to speak to them, both orally and on paper—to make such impassioned statements as this:

> The ideal of the day was that "women must be pretty, dress prettily, flirt prettily, and not be too well informed"; . . . that she had no God-given destiny, no soul with unquenchable longings and inexhaustible possibilities—no work of her own to do and give the world—no absolute and inherent value, no duty to self, transcending all pleasure-giving that may be demanded of a mere toy; but that her value was purely a relative one and to be estimated as are the fine arts—by the pleasure they give.

The "no" she places before each phrase is but a rhetorical sleight of hand; the real energy and force of this passage lies in the self-description of women with "unquenchable longings and inexhaustible possibilities . . . absolute and inherent value." Cooper needs that facility of voice to perform her persuasive tricks and to encode her own complex intellectual inheritance. She takes what she needs, offering critiques and then using the wisdom she gleans unapologetically. She cites Macaulay, Emerson, Tacitus, Ovid, Longfellow, Thackeray, Lessing, Voltaire, Fenelon, Whittier, Carlyle, Milton, and Lowell—all referred to by the shorthand of a single name, demonstrating the author's easy familiarity with these writers

and presumptions that her audience will know of whom she speaks. Cooper criticizes these writers but as readily engages them at the level of intellectual sparring between equals: if their words do service to her textual aims, they are quoted; if she needs to take issue, then she does. This is what it means for Cooper to "be about our Father's business."

Cooper does much to establish the presence of African Americans and women in history and on the public landscape, even when they are unheard. This was common practice at a time when the simple accounting of "race leaders" was crucial work that made those bodies exist in a vacuum. Mrs. N. F. Mossell's *The Work of the Afro-American Woman*, published in Philadelphia in 1894, chronicles the accomplishments of professional African American women. It is a compendium that seems to be attempting to list everyone, not to miss a soul: writers, educators, musicians, missionaries, businesswomen (undertakers, farmers, inventors, innkeepers, even women in the sand-hauling business), "race uplifters" all. Listing their names and what they have done asserts that the intellectual and professional terrain has been marked by the presence of African American bodies. Although Mossell's book is more conciliatory in tone than is Cooper's, the latter cleared important space for both *The Work's* chapters such as "A Sketch of Afro-American Literature," "Our Afro-American Representatives at the World's Fair," and "Caste in Universities," and for Mossell's movement from analytical essays to her own poetry—in short, a literary space that could contain any number of different voices and modes necessary for making the point. This

book and other turn-of-the-century African American texts, such as D. W. Culp's anthology *Twentieth Century Negro Literature* (1902), speak to Cooper's message: that the accomplishments of each African American reflect on the group as a whole, and that this nascent "talented tenth" might represent a bringing along of those who have not yet had the opportunity for similar accomplishment. Perhaps this small class of people was struggling to prove even to themselves that there was such a thing as a viable, empowered African American intelligentsia in a world that continually asserted otherwise.

Cooper's African American intellectual sisters do not have the same written legacy as the white men from whom she quotes—Frances Harper's *Iola Leroy* came out in the same year, and Hallie Q. Brown's *Homespun Heroines* and Amanda Smith's autobiography would not be published until several years later. To treat their thoughts with the same respect and give them the same rhetorical space Cooper can but invoke their thoughts and their existence, as she cannot yet quote from many of their books. Of her community, she states:

> To be a woman of the Negro race in America,
> and to be able to grasp the deep significance of
> the possibilities of the crisis, is to have a heritage,
> it seems to me, unique in the ages. In the first
> place, the race is young and full of the elasticity
> and hopefulness of youth. All its achievements
> are before it. It does not look on the masterly
> triumph of nineteenth century civilization with
> that *blasé* world-weary look which characterizes

the old washed out and worn out races which
have already, so to speak, seen their best days. . . .
Everything to this race is new and strange and
inspiring. There is a quickening of its pulses
and a glowing of its self-consciousness. Aha, I
can rival that! I can aspire to that! I can honor
my name and vindicate my race! . . . Not the
photographer's sensitized plate is more deli-
cately impressionable to outer influences than
is this high strung people here on the threshold
of a career. What a responsibility then to have
the sole management of the primal lights and
shadows! Such is the colored woman's office. She
must stamp weal or woe on the coming history
of this people. May she see her opportunity and
vindicate her high prerogative.

She moves in and out of identifying with "the race,"
speaking to, about, and of it at the same time. When she
introduces the bodily metaphors of quickening pulses, she
brings in the first person; even though this is a projected
first person, it functions in this text, with its multipurpose
"I's", to remind us of who here speaks. This passage dem-
onstrates how her own sense of mission is inextricable
from a collective sense of mission. She speaks simul-
taneously in third-person rhetoric: she can see, from a
distance, the great gifts of African American people and
their position in history at the same time that she speaks
with privileged information that would not be accessible
to an outsider. In that shifting "I," she simultaneously
makes a space for the community to exist and from which
she can speak.

When the text opens, Cooper's "I" is at its farthest
distance from her lived experience, utilized as a rhe-
torical tool expressing conventional formality toward
readership—"I confess," "I would beg," and the like. As
we will see later, when "I" is used forcefully in what is
perhaps Cooper's most famous passage, she places that "I"
in quotation marks, no longer explicitly the speaking nar-
rator but someone quoted. She speaks of simultaneous
singularity and collectivity, a multiplicity of voices and
perspectives at play at once. The frontispiece of her book
lists "A Voice from the South, by a Black Woman of the
South" as the author. She is not anonymous—her name
appears in the copyright on the next page as "Anna Julia
Cooper"—but, rather, "a Black Woman of the South" is
actually her name on the frontispiece. She is singular, "a"
black woman, but she is also, by lack of a proper name,
representative of many. "A Black Woman of the South"
is Cooper's alter ego, her nom de plume within the text
into which she can insert her lived experience at a point in
an argument where she feels that very experience might
be discredited. In calling the first section of the book
"Our Raison d'Être," she again presents herself as part of a
group as she defines the group's very reason for existing.

In her best-known statement, Cooper addresses the
question of the collective further: "Only the BLACK
WOMAN can say 'when and where I enter, in the quiet,
undisputed dignity of my womanhood, without violence
and without suing or special patronage, then and there
the whole *Negro race enters with me.*'" Cooper articulates
a philosophy that runs directly counter to the notion of
the singular intellect or genius. For her, genius works in

service to the race. Again, she constructs a physical meta-
phor to describe the fruits of metaphysical inquiry, paint-
ing an idea of "the whole Negro race" as bodies moving
into a literal space where before they have been tangibly
unwelcome. "BLACK WOMAN" is in large, bold, capital
letters, its body standing taller and stronger than anything
else in the sentence, asserting its right to space. She tem-
pers the statement, again I would argue, for a skeptical
audience, by invoking the idea of ladylike-ness. She will
not go through the courts; she will go without "violence";
she asks for no "special patronage," but she will assert her
presence. Cooper may not be realistic about the privileges
her class status and attainment have offered her. As we
have already seen the "masses" of African Americans
she refers to earlier is a group who "wrought but they
were silent," and this silence is distinctly different from
speaking but not being heard. Nonetheless, if Cooper
has found her individual voice, she seems intent on mak-
ing it work to the service of a larger racial good.

Perhaps the most noteworthy narrative strategy of
that chapter involves the use of quotation marks. For
who, exactly, is she quoting? Several years later, as Mary
Helen Washington observes, Du Bois quotes that very
same passage—"only the black woman can say 'when and
where I enter'"—and attributes it not to Cooper spe-
cifically but merely to "one of our women." Who is "the
black woman" quoted in this passage who speaks these el-
oquent words? It is Cooper herself. She is quoting herself,
her own earlier spoken words, within this written text.
This sets the quotation apart from any spoken version of
the work, where no one would know, unless she said who

was speaking, that she was moving into a different voice. It is important, then, to remember the oral dimension that is ever present in Cooper's work. If someone else said those words, she would have needed to quote them more explicitly. Even Du Bois said more, though not enough, when he attributed it to "one of our women." She has already told us, on the frontispiece, that she is "a Black Woman of the South." By putting the words in quotation marks she valorizes and sets off the import of the words just as she does when she sets off a passage from Milton. She is making that which has existed only as spoken wisdom part of the written, quoted record. Yet it is as though she knows her own author-ity is under siege before she writes a single word, so she elides her first-person perspective into a clue-laden, newly created hybrid or collage of third and first person. She sits simultaneously in both narrative positions at once, inhabiting them as need be to most persuasively state her case.

Just two pages later, we see the first instance in which she unambiguously employs an extended first-person meditation and her own lived experience as persuasive empirical evidence. She prefaces the story of her time as a student at St. Augustine's with an elaborate asking of permission from the reader for the right to insert her body in the space of empirical evidence: "My readers will pardon my illustrating my point and also giving a reason for the fear that is in me by a little bit of personal experience." She then tells how there was literally no space made for her in the classroom in St. Augustine's. She makes a space in the text for her story, which is a story of educational exclusion in which space was made for "ministerial

candidates (many of them men who had been preaching before I was born)" while Cooper, an "ambitious girl," feels constantly "a thumping from within unanswered by any beckoning from without." Once again, spiritual and intellectual longing is physically palpable; it is the body as well as the mind that experiences this spacelessness. When she is finally able to study Greek, which she wants desperately to do, she again gains a seat in the classroom and therefore a space in the text to unleash the depths of feeling. She quickly loses, at this very moment, the colloquial "I" we have just seen, but not without tingeing it with sarcasm, her clue to the reader as to how to read her tale: "I replied—humbly I hope, as became a member of the female species—that I would like very much to study Greek, and that I was thankful for the opportunity." She then drops the "I" and unleashes her torrent:

> A boy, however meager his equipment and shallow his pretentions, had only to declare a floating intention to study theology and he could get all the support, encouragement and stimulus he needed, be absolved from work and invested beforehand with all the dignity of his far away office. While a self-supporting girl had to struggle on by teaching in the summer and working after school hours to keep up with her board bills, and actually to fight her way against positive discouragements to the higher education; till one such girl one day flared out and told the principal "the only mission opening before a girl in his school was to marry one of those candidates." He said he didn't know but it was. And when at last that

same girl announced her desire and intention to
go to college it was received with about the same
incredulity and dismay as if a brass button on
one of those candidate's coats had propounded a
new method for squaring the circle or trisecting
the arc.

In short, Cooper here presents the facts of her own life,
minus the "I" that marks her as Anna Julia Cooper but
also as African American, female, and therefore nar-
ratively unstable. From her first educational experience
she has been deemed unworthy of learning, as intellectu-
ally capable as a "brass button." The space of persuasive
rhetoric has remained inhospitable to African American
women. The realm of "truth," of third-person empiricism,
has not been the domain allocated to African American
women. Cooper temporarily erases her black and female
body so that she might make a space for it, slightly re-
figured, in a hostile domain.

It is in the process of travel that we see her, for the
first time, engaged in the act of intellectual contempla-
tion and writing, the distillation of her own experience
into words. "I see" from the window, she tells us, teenaged
boys working on a chain gang. Her response: "I make a
note on the flyleaf of my memorandum, *The women in
this section should organize a Society for the Prevention of
Cruelty to Human Beings, and disseminate civilizing tracts,
and send throughout the region apostles of anti-barbarism
for the propagation of humane and enlightened ideas.*" This
is written at the same time in which Ida B. Wells is just
beginning to travel the country protesting lynching. An

African American woman traveling is one thing, but for her to be traveling and working and for that work to be committed to social change is a risky situation indeed. Cooper's showing herself in the act of writing while traveling accomplishes several things: first, it "lets on" to her readers—for here she moves fully into the first person—that these stories we have been hearing are from her own personal experience. Second, she writes a space for herself and her type: the working African American woman writing and traveling through the South with neither husband nor father, nor other companionship—simply herself and her intellect. It puts the body in that space, writing.

Cooper chronicles the unchronicled logic of her own intellectual processes at the point in history when her body was only newly her own legally. Yet for Cooper, the individual ideal does not exist without a group ideal, even when the two oppose each other in degrees. In short, the self-presented vision of the turn-of-the-century African American person of letters cannot exist without a concurrently articulated sense of place in the culture at large. *A Voice* is the work of an individual who necessarily is, in Du Bois's memorable words in *The Souls of Black Folk*, "bone of the bone and flesh of the flesh" of the group of which she writes.

Cooper states that her words are to represent "that muffled chord, the one mute and voiceless note [of] the sadly expectant Black Woman." From that first moment, she aligns her self with a group larger than just herself. She exhorts her readers to recognize a "raison d'être" not only for being but for writing about these very subjects

that concern the widening of opportunities and visions for African American people: "It is not the intelligent woman vs. the ignorant woman; nor the white woman vs. the black, the brown, and the red,—it is not even the cause of woman vs. man. Nay 'tis woman's strongest vindication for speaking that *the world needs to hear her voice.*" Thus the "auto" of autobiography no longer means "self" in the literal sense, just as here Cooper conflates the very notion of single self-authorship with collective voice and responsibility. As Cooper creates her self in writing, she forges a space for the unimagined African American woman intellectual, working and thinking at the turn of her century, and this one.

A BLACK MAN SAYS "SORBET"

⬥

I. BLACK MAN

"When you're a black boy," writes Scott Poulson-Bryant, "—whether under streetlights or spotlights or siren lights—being onstage is a way of life."[51] Whatever our vantage point, we are all watchers of black men. In the 1990s Court TV shifted between O. J. Simpson and Colin Ferguson, the accused Long Island Rail Road–gunman who defended himself in court. In the Simpson trial, it was not only Simpson on display; the rhetorical rhumba of attorney Johnny Cochran played against opposing Assistant District Attorney Christopher Darden's anemic entreaties. Switch the channel and black men are slam-dunking, rope-a-doping, and end-zone dancing. Or they are imagined as faceless criminal nightmares. Charles Murray's *The Bell Curve* is only one contemporary redeployment of the mythology of black male penis size. The act of Michael Jackson showing his genitalia to Santa Barbara police was national news. Susan Smith's phantom black male murderer—his "composite sketch" was circulated even after Smith revealed that she created him from whole cloth—showed that when no actual black man is present, we remain riveted by his imagined,

ghostly power, which Cornelius Eady unfurled so haunt-
ingly in his poem (and later play) "Brutal Imagination."

Certain kinds of black men's stories are ever in vogue,
stories that offer the easy paradigms of criminality and
putative redemption in books like Nathan McCall's
Makes Me Wanna Holler, Monster Cody's *Monster*, Ice-T's
The Ice Opinion, and many others as well as filmic texts
too numerous to name. The black male protagonist's
proximity to the criminal justice system is what makes
these works familiar, as well as the way that they follow a
recognizable Augustan formula popularized in the slave
narrative and *The Autobiography of Malcolm X*. These
characters are early sinners who redeem themselves in
confinement. They are domesticated within the confines
of a prison (Cody), a newsroom (McCall), or the pages
of a book.

A Nike commercial from the 1990s shows black men
in a barbershop, laughing and talking while "Express
Yourself" by Charles Wright and the Watts 103rd Street
Rhythm Band plays in the background. For black men
in America and elsewhere, to "express" themselves in
words or images rather than with the body, is usually
represented (or, more to the point, not represented) as a
private activity, reserved for the space of the barbershop
or the early 1970s nostalgia evoked by the song in the
advertisement. When do we see black men telling us how
they live and think beyond the clichés of "gangsta" and
"hood," which purport to give the "real" story of black
male life behind bars or behind the trigger finger? These
black men's lives are made more valuable, more consum-

able, by familiar notions of ghetto authenticity. I am not interested in which images are "positive" and "negative" but rather in the familiar and oft-utilized scenarios that make us think what we are seeing is "real," and that skew the picture of how black men are thinking about and presenting alternative public selves.

The public spectacle of black men invokes simultaneous fantasies of desire and dominion, titillation and domestication. Take, for example, the courtroom moment when full-blown pictures of O. J. Simpson in his underwear were shown to the jury and millions of television viewers. Simpson then walked up to the jury and pulled up his pants leg to show them his bare, injured knees. The black athlete's near-naked body "spoke" when he could not (the judge refused Simpson's unprecedented request to address the jury verbally during his lawyer's opening statement), thus invoking the forbidden spectre of black male mythological sexuality. In the 1920s, the boxer Jack Johnson embodied familiar stereotypes of black male physicality, a physicality writ sexual by his body's muscularity and near-nakedness in tights. In the ring he was, in the words of the poet Robert Hayden, "gracile and dangerous," accessible to any viewer's sexual imagination yet spatially contained by the ring. It was his unabashed taste for white women that made him a threat to white America; the Johnson paradigm echoes behind the O. J. Simpson story. I am black and beautiful, sexual and dangerous, Simpson's body says to the jury and to the millions of Americans watching on television, but I am contained within the frame of the still photograph. I am

a domesticated beast, his body says, You might fantasize that I will hurt you, but from my cell, or this photograph, how could I? Titillation and containment, desire and dominion, are intricately united. *Time* magazine significantly darkened Simpson's skin color on their cover, thus emphasizing an idea of him as a stereotypic "black" predator. But the photos of Simpson were photos, after all, and the man who showed his famous knees would return to a prison cell that night. This dynamic explains a great deal about the cannibalistic gusto with which so many black men's stories are contained and consumed by the larger populace.

When accused subway gunman Colin Ferguson represented himself in court, the media seemed unable to understand him as a product of the black Jamaican elite. What images of upper-class black men, West Indian or not, do we see in America? Ferguson had absorbed enough lawyerly language to perform the role of "lawyer," much to the amazement and amusement of the courtroom and the televised audience. But just as poor black and Latino drag queens in Jennie Livingston's *Paris Is Burning* could "play" roles like businessmen and preppies in Harlem's drag balls, Ferguson, too, has entertainment value precisely because he is domesticated. Everyone knows he's going to jail; everyone thinks he committed the crime; everyone knows his lawyering is a performance; most importantly, everyone is certain he is crazy. There is something tragically familiar about this drama playing itself out to its inevitably sorry conclusion before so many viewers. I was fascinated with Ferguson because as I listened to the commentators on television, I

knew they had absolutely no idea who he was, just as so many art-world racists could only imagine Jean-Michel Basquiat as a savage-savant, and therefore not as someone with purpose, tutelage, family, history of whatever kind. Many of those same people also imagined Basquiat to be the beginning and end point of African American art history, as though there had been no Henry Ossawa Tanner, Bill Traylor, Charles Alston, Lois Mailou Jones, Romare Bearden, Beauford Delaney, Jacob Lawrence, or Emma Amos (to name only a few, and randomly) painting before him, nor Kerry James Marshall, Robert Colescott, Howardena Pindell (again, to chose randomly from scores of others) painting alongside him.

Jazz trumpeter Louis Armstrong grinned expansively during his performances, but the sheer expressive power of his fierce, virtuostic playing belied the eager, amiable façade. Earlier, at the turn of the century, Paul Laurence Dunbar described that same phenomenon with his lines, "We wear the mask that grins and lies, / It hides our cheeks and shades our eyes, / . . . With torn and bleeding hearts we smile, / And mouth with myriad subtleties." From behind the public face, black people have long known how to "mouth with myriad subtleties" and subvert that public face, sending multiple messages in their performances that signify meaning far beyond the stereotypical. Basquiat, we must assume, knew this in some way, too, and signified to his Haitian/Puerto Rican heart's content, code-switcher extraordinaire both in the work and in his dealings with those who would promote him without any idea of who he really was.

II. WILD CHILD

"Outré": exaggerated, eccentric, bizarre
"Eccentric": deviating or departing from the center

In a *New York Times* article on Julian Schnabel's film *Basquiat,* the accompanying photograph shows Jeffrey Wright, the actor who plays Basquiat, crawling on the floor in what appears to be a diaper, and nothing more. Art historian Robert Farris Thompson has sardonically characterized the white art establishment's attempt to label Basquiat "Afro-Mowgli, untutored wolf-child of the Brooklyn streets."[52] In the newspaper photo Wright-as-Basquiat is cast as the feral, black fantasy baby.

Thompson, Greg Tate, and bell hooks have persuasively debunked Jean-Michel Basquiat's savage-savant, art-world mythology, discussing instead the complex ups and downs of the talented, notoriously troubled artist's life and work, and Kevin Young devotes an entire collection of poems to the artist's legacy.[53] Many of Basquiat's fans have seen a neo-primitive, atavistic appeal in his work, but as Thompson says, the art was "more than bones and texts."[54] Thompson takes special pleasure in identifying and discussing Basquiat's Afro-diasporic-ness (his mother was Puerto Rican and his father, Haitian), commenting on the artist's alternating English with "beautiful Caribbean Spanish." Negro authenticity may be sexy, but the real particulars of black lives audaciously challenge that particular appeal.

The illusion that Basquiat was a wild child, living always and only in the moment of utterance, prevents

a more complex understanding of his work and par-
ticularly its sense in black contexts. Certainly, stories are
legion and legend of a drugged-up Basquiat barricaded
in a studio in a narcotic haze, churning out picture after
picture that were snatched away and sold. But Basquiat
was, in fact, also a doomed black aristocrat, a master of
outré Afro-aesthetics who styled and profiled outside of
many boundaries. In photographs and articles, Basquiat-
père (Gerard) appears rigidly elegant, a Haitian aristocrat
who drives expensive European cars and plays ten-
nis. Scarcely any written account of Basquiat has been
able to amalgamate the pop-food Basquiat narrative
with actual biographical details. In James Van Der Zee's
beautiful photograph, Jean-Michel is the bad boy at his
beloved grandfather's getting his picture taken. That pho-
tograph is in continuity with the elegant, imperious black
Gothamites in Van Der Zee's "Couple in Raccoon Coats"
of some fifty years earlier.

Basquiat may have told an interviewer that his sub-
jects were "royalty, heroism, and the streets,"[55] but he also
understood, in his painting *Charles I,* that "most young
kings get their heads cut off." I believe Basquiat must
have understood that he would never be fully compre-
hensible by the white art world that so touted him. He
was an aesthetic outlaw who fell outside the predict-
able imaginative boundaries of black criminals. He was
therefore unimaginable, and his transgressive, outré Afro-
aesthetics are lost in that unimaginability.

Where Whitney museum curator Richard Marshall
sees and privileges the influence of Jean Dubuffet, I

see Romare Bearden's series, "The Block." A Basquiat 1981 cityscape, *Part Wolf* (1982), reminds him of Jackson Pollock, me of Bill Traylor. *J's Milagro* makes him think of Robert Rauschenberg; I think of the painter Bob Thompson. None of this is to negate the multiracial influences that suffuse the work of any great artist. Rather, I mean to make a point about myopia. When Basquiat's not being called a savage, he's being called brilliant because of the way his work is supposed to pay homage to white artists. The point is not, can we document what Basquiat actually looked at, though that is certainly interesting. The point is, what do critics, whose job it is to see and contextualize, bother to know about black artists and how do the limitations on that knowledge make them canonize a Basquiat who only makes sense in the most offensive racial scenarios?

Basquiat's work is made for other men. His white male admirers are on record; I know many young black men, heterosexual, sexually complex, for whom SAMO—Basquiat's early graffiti tag and nom de guerre—is God. His fiercely intelligent work (work "*about* knowing," in the words of Robert Storr[56]) and thrilling high-wire chutzpah encoded a blackness to be read and deciphered. If you can "read" this work, it suggests, then you can be a smarty-pants, too. These drawings are filled with glyphs, words that do not lead to tidy comprehension. As Greg Tate writes:

> Talking about Basquiat is also talking about my
> generation. Born into a world of monster movies
> and science fiction, comic books and cultural

> nationalism, parliament-funkadelic, hip-hop and
> punk rock. And if you're a young black person
> you're constantly trying to square the futurism
> of America with the barbarism of the place. So
> we live in a multiplicity of imaginative realms,
> the world of the technocrat and the world of the
> dixiecrat, savage Africa and Africa as paradise
> lost. We live in a world of signs and ciphers we
> manipulate to perform symbolic magic of our
> own devise. We ironically respond to language
> as a tool of oppression by disempowering it with
> crazed black wit.[57]

Basquiat's work relishes the visceral experience of reading
as well as the acts of attaining and displaying black male
knowledge when the world wants to see you as all brawn
and penis and savagery. Basquiat's work is a meditation
on the science of outré black elegance and offers a kind
of black male brilliance, a potential paradigm for other
artists' work.

III. "BRILLIANT BOY ABOUT TOWN"

The archive I assemble here is generically eclectic: visual
artists, characters in movies and plays based on real-life
people, and real-life stories of regular lives rendered artistic
in the act of flamboyant living. Taken together, they illus-
trate both the limited mainstream imaginative capacity
around black men, as well as the conscious creation and
enaction of inventive, sometimes destructive, black male
personae.

The relationship between the real-life story of David Hampton, the young black man from Buffalo, New York, who came to New York City at age seventeen and, in his words, "became a brilliant boy-about-town,"[58] and John Guare's successful play, *Six Degrees of Separation,* which is based on Hampton's story, tells us a great deal about the unimaginable, outré black male aristocrat. Hampton's fifteen minutes of fame came when, posing as actor Sidney Poitier's son, he gained entrance into the homes of wealthy, well-known white New Yorkers by claiming to be a school friend of their children. His hosts ultimately unraveled the scam after Hampton was found in bed at their home with another young man. In a play, which is otherwise unusually faithful to the story that inspires it, the author makes crucial changes that allow him to avoid contending with the thornier intersections of race and class.

Guare's play is ultimately unable to contain the ways in which race, sex, and class bleed into one another, both deliberately and not, despite the play's claim that each person is separated by only six people, "six degrees." Guare constructs the class pass and a world in which people are safely on sides that they pass over if societal boundaries are to be transcended. Hampton's actual life calls attention instead to boundaries that have already been transgressed, with unsettling consequences.

The Paul of *Six Degrees* comes into the lives of wealthy, white New Yorkers Ouisa and Flan Kittredge claiming to have been mugged and gains entrance to their home by proferring details of their children's lives at Harvard. Flan is an art dealer entertaining a visiting white South African client, and Paul turns the evening magical for

them with his stories of his "father" Sidney Poitier's im-
minent arrival to cast the movie version of *Cats* (in which
he promises small roles for his hosts). He also offers ac-
counts of the Kittredge's children's love for them when, in
fact, the children are alienated from and disgusted with
their self-consumed, social-climbing parents. Paul is a
bricoleur who, according to Flan, "sort of did wizardry"
with "an old jar of sun-dried tomatoes . . . tuna fish . . .
olives . . . onions" to make dinner for them. He is found
out when Ouisa, after inviting Paul to spend the night,
finds him in bed with a man. From there the play turns
more sinister; Paul meets a young naïve white couple who
have come to the big city to be actors. Paul seduces the
young man after dancing the night away at the Rainbow
Room on the couple's money, and the fellow is so dis-
traught he kills himself.

The character Paul is without given background or
history of his own, but we do learn that he was tutored by
a wealthy young white man on the ways of wealthy white
folks. Trent instructs him in exchange for sex: "This is
the way you must speak. Hear my accent. Hear my voice.
Never say you're going horseback riding. You say you're
going riding. And don't say couch. Say sofa. And you say
bodd-ill. It's bottle. Say bottle of beer. . . . Rich people do
something nice for you, you give them a pot of jam." Paul
steals Trent's address book and begins his Fifth Avenue
ascent.

Like the mythological Basquiat, Guare's Paul is a
savage-savant who comes from nowhere and infiltrates
the white upper class. Although the play points out the
extent to which the parents don't know what is going on

in their children's lives, it nonetheless makes blackness and homosexuality an outside toxin that must cross a boundary in order to taint the parents' world. Guare critiques their worldview—toward the end, Ouisa says: "He wanted to be us. Everything we are in the world, this paltry thing—our life—he wanted it. He stabbed himself to get in here. He envied us. We're not enough to be envied"—but he nonetheless sees race, class, and sexuality in fixed paradigms wherein borders can be clearly delineated and crossed, or not.

The real-life Paul is not an Eliza Doolittle in need of tutelage on the rudiments of class. In fact, Hampton (who died of AIDS in the summer of 2003) is a product of the black upper-middle class in Buffalo, New York, who attended many of the same elite prep schools as the white people whose lives he enters. He describes his life in Buffalo as follows: "There was no one who was glamorous or fabulous or outrageously talented there. I mean, here I was, this fabulous child of fifteen, speaking three languages, and they didn't know how to deal with that." He told his story on *The Phil Donahue Show:*

> Hampton: I came from a family in upstate. My parents were both respectively the first ones in their families to go to college. My father was and is a lawyer and basically said to me, "You are going to do something civilized and sane, so that means that you're going to go to college and you're going to become a doctor, a lawyer or a stockbroker."
>
> And I said, "No, I want to go into the arts." And so we had a showdown and I pulled his

trump card. He said that if I would not do what
he wanted me to do, he would not support me.
So I ended up coming to the city trying to get
acting jobs and modeling jobs and could not get
them because I would go in and people would
look at me and they would go, "We'll make you a
Latin." Or—they wanted to do everything ethnic
because I do not have distinctive black features.

Donahue: You're not black. You're not white.[59]

His "showdown" with his father quickly ushers him out
of the category of "black," both in his own narrative and
to Donahue. But more crucially here, Donahue could not
imagine or understand him as a black boy not from the
street. Hampton literally could not be black in Donahue's
imagination with his background. It would be much
more threatening for *Six Degrees* to suggest that these
classes have not been infiltrated at all, in fact, that the
David Hamptons of this world already go to school with
white children who don't need an outsider with "this wild
quality" to make boys have sex with boys.

Six Degrees assumes the black, gay, economically
impoverished—read culturally bereft—"other" wants
white legitimacy (Paul changes his moniker to Paul
Poitier-Kittredge) after the white father whose own
children loathe him. But this "passing" ultimately shows
a reader or spectator much more about the white upper-
class people who unwittingly have a transcendent experi-
ence than it does about the catalytic main character, who
remains a cipher to the audience in the way that so many

insistently see their "others." The imagined stories are so much easier to digest than the truth, just as Basquiat/ wolf-boy is easier to understand than a more complex and contradictory black figure.

Black, Ivy-League educated, Manhattan lawyer and author Lawrence Otis Graham wrote cover stories for *New York* magazine in 1992 and 1993. In the first, titled "Invisible Man," Graham went "undercover" as a $7-per-hour busboy at the Greenwich (Connecticut) Country Club in order to "find out what things were really like at a club where I saw no black members."[60] He reports back a predictable roster of indignities from "a place so insular that the word *Negro* is still used in conversation." Perhaps this remark might be insightful had Graham achieved his stated goal of "get[ting] close enough to understand what these people were thinking and why country clubs were so set on excluding people like me." But Graham's attitude is ultimately a petulant indignance that "people like me" can't be part of the racist, classist world he so condemns. He sneers at the very people he is trying to "be." In order to "de-class" himself, as it were, he puts on "a polyester blazer, ironed blue slacks, black loafers . . . a horrendous pink-black-and-silver tie . . . and arrestingly ugly Coke-bottle glasses."

Graham constantly brandishes his own privileged class status as his authority to speak for "the other." The article includes press clippings about him from the Princeton University newspaper and a photograph of him dancing at his wedding with his wife, who he tells us is also "brilliant" and "Ivy-League educated." He hides his "American Express gold card . . . Harvard Club mem-

bership ID, and all . . . business cards" from his coworkers. The headline tells us that his salary (in 1992) is $105,000 a year, and that his busboy's salary was "less than one tenth of what he earned as a lawyer." The final picture of the article shows him back in his pinstripe suit and briefcase, standing outside his law firm.

In his next article, Graham poses as an aspiring writer and "jazz oboist" in a Harlem rooming house to tell the ostensibly "real" story of America's best-known and most-mythified black burg. That cover reads, "The 'Invisible Man' checks into a West Harlem rooming house and moves between the deadly, stoned world of the streets and the proud sanctuary of Strivers' Row." His costume for this escapade is a "fade" haircut, "dark unlaced work boots, black sweats, a $199 gold chain with an Uzi pendant, Malcolm X cap, Sony Walkman earphones, black knapsack, dark sunglasses, and a black Dr. Dre T-shirt that said I GOT TO GET F---ED UP, I screamed ghetto defiance."[61] Here, too, in the same way that John Howard Griffin and Grace Halsell used their whiteness to authorize them to speak "for" blacks in *Black Like Me* and *Soul Sister,* Graham constantly reminds his readers of the authority that class confers upon him to speak for the lives of others. Once again, he tells us, he is hiding money, credit cards, and his Princeton class ring and leaving messages on his accountant's answering machine. He goes "undercover" long enough to report back on a gallery of ghetto stereotypes (he chooses the monikers "Peaches" and "Jojo" for two of his characters), and then, like Superman, changes back into his business clothes and hightails it back to his life.

Both Hampton and Graham, young, upper-middle-class black *poseurs,* have been on the cover of *New York* magazine, and by the yardstick of *Six Degrees* and the letters column, both captivated the imaginations of many New Yorkers. What is the hunger for these stories rather than the "real" stories of these young men's lives? Why are fictitious, stereotypical black men so infinitely credible?

IV. "JUNIOR"

Wendell Harris's film *Chameleon Street* won the 1990 Grand Prix at the Sundance Film Festival. This film is also based on the true story of a black Detroit con artist named William Douglas Street who poses, among many identities, as a Harvard-trained surgical resident and a Yale graduate student. Street is a disaffected, desultory antihero whose motto is, "I think, therefore I scam." He is misogynist and drolly detached but nonetheless compelling, even as he screams, "This is BORING," while working for his father's burglar-alarm-installation company. He is divorced and lives at home with his parents and pain-in-the-neck little brother. Street is driven by the refrain, "make some money." He doesn't want to make money for his second wife's desires: charge cards at Bonwit Teller and Neiman Marcus. Rather, money is a way out from a geography, lifestyle, and legacy that Street finds stultifying.

Street has the trickster figure's particular gift; like Hampton, he says, "When I meet someone, I know within the first two minutes who they want me to be." He tries extortion and slithers out of the botched at-

tempt by becoming a media mascot. He fakes being a *Time* reporter in order to interview foxy basketball star Paula McKee. As a resident surgeon from Harvard, he successfully performs a hysterectomy. He poses as "Pepe Lamopo," a Yale exchange student from Martinique, who cannot speak French but watches Edith Piaf tapes and spouts, "J'accuse Jacques Brel. J'accuse Jock strap." These masquerades reveal what Hampton exemplifies about how the signifying monkey can learn many of the ways of white folks. Indeed, *Chamelon Street* acknowledges its roots in the tradition of the African-diaspora trickster with the story of the scorpion and the frog that is told over the credits. Why is the scorpion wily? Why does the scorpion sting? "Because it's my character," says Street, for the last words of the film.

In the film, the character Street says that it was "too easy" posing as the doctor. For he is verbally acute and perhaps brilliant; the movie has us think that part of the reason (the main one being depression or some other more internal malaise) Street needs to scam is that his color has limited not only his accomplishment but his very perception of his opportunities, his imagination, which then flowers in the scams. Street is caught each time and spends time in prison, where, in an interview with a prison psychiatrist, he ruminates on the title *Notorious Negro* for his autobiography.

Street's father looms in the background of this film. Street clearly sees his father as someone with a dim life who "settled" into his life as a Detroit burglar-alarm installer, even if he might have taken advantage of what little opportunity there was for him. The senior Street's

disappointment in his son is also clear; he hangs up the phone on his son when the younger man calls from prison. But at his final arrest, when a police officer asks, "Are you William Douglas Street?" the con man ruefully answers, "Yes. But don't forget the Junior." He would not bring shame upon his father by allowing the two to be confused, but at the same time he feels imprisoned by that paternal legacy. He can never forget he is his father's son.

Hampton and Street both clash with middle- or upper-middle-class black fathers who hope to continue their lineage through their sons. "My father has a receding hairline like mine," Hampton has also said, "which gives you a certain *forwardness,* that Barry Diller receding hairline, where you sort of feel the brain cells *leaping* out at you—either that, or it's like Malibu beach that is being pushed back as the weeks go by."[62] Character and characteristic have here become one; Hampton seems to want his phenotypical inheritance to say something about his "legacy" from his father.

Hampton (the person) and Street (the character) both call on the traditional signifying strengths of blackness, the ability to read the dominant culture better than it reads itself. But what is noteworthy here is their places in the black families, specifically with regard to the black fathers they left behind but with whose legacies they continue to wrestle.

These men attempt to distance themselves from stereotypical black-pride rhetoric, assuming at times a certain narrative ennui—a middle-class version of the street-style "cool pose," perhaps—that belies a deeper

and more fundamental rage at both received Civil Rights rhetoric and attendant narratives of patriarchal black manhood, which, in some fundamental way, have left them feeling both constrained and at sea. This is paradoxical in the era when discussions of the literally absent black father do not consider families with intact fathers who nonetheless did not provide a portable legacy for their sons striving to find themselves in post–Civil Rights America.

I say "they" but of course I am also talking about men with whom I feel an affinity that is at the very least demographic. The young men I have known who make me think of Jean-Michel Basquiat are as brilliant and bratty, believing of their own hype, sleeping with women but preferring each other's company, materially and intellectually privileged, relentlessly clever, disdainful of school, deliberately indecipherable, smarty-pants, eclectically well-read, lovers and collectors of words in English and other languages, lovers of hard, hard music, radiant, nasty trouble-children. Those boys made me angry, exasperated, anxious. I have known the "Bourgeois Babies" who choose not to speak to me on the street, who insist on a color-blind world. But as I think about Jean-Michel Basquiat, I wonder what sort of conversation I would have had with him, had I ever met him. It's presumptuous to think that all black artists in some way belong to each other, are part of the same large and bumptious family, but I'm a weird sister ever-searching for her strange black artist brothers. I also think that all art, in its individualistic howling, is unwittingly looking for a context, a place to make, or stop making, sense.

The filmmaker and artist Arthur Jafa keeps a list of words he's never heard black people say on film:

> Like, I've never heard a black man say "sorbet" in a movie. On the most trivial level, that's about de-essentializing blackness. It's about opening up spaces around black men. I liked one of my best friends from the first time I met him because he was the only black man I knew who would use the word "exquisite." It's about consolidating blackness and, at the same time, opening up the space we can be black inside of.[63]

The fissures of space in the mainstream imaginary in which black men can move have been notoriously narrow and burned into our subconsciousness in such a way that when black men break the frame, we are blazingly aware of it. To be outré, or, in the vernacular, OUT, to step on the cracks, step outside of the boundaries meant to contain the varietal might of black male expressivity and imagination, is instantly, symbolically, quite utterly devastating. Basquiat is both "in the tradition" and new, which changes our understanding of boundaries and transgression and marks more turf in which black male expressivity can BE.

DENZEL

•

We call him by his first name, this post–Civil Rights Sidney Poitier, this respectable icon, this neo-noble Negro who keeps his undershirt on while making love in Spike Lee's *Mo' Better Blues* and famously doesn't get to kiss the white girl in *The Pelican Brief,* but who nonetheless moves selfsame white girl to practically wrap her legs around his waist on the historic Oscar night when he wins Best Actor, revealing what we all knew her onscreen character wanted to do with his fine brown frame all along. And who can blame her?

I have come of age along with Denzel after first seeing him in the Negro Ensemble Theater stage version of *A Soldier's Story* in the early 1980s. He was always on that screen, with a sterling work ethic and thus now with a formidable body of work that bears investigation. It is easy to get caught up in his physical beauty. It is extreme but somehow accessible; he is handsome in a finest-brother-on-the-block way rather than the dermabraded Hollywood pretty-boy fashion. He is always, to use the vernacular, clean. But in this most image-conscious of industries, notoriously wretched when it comes to representing and hiring black people, he has found a way to

assemble a quite remarkable gallery of black male characters for our age that are neither stereotypical nor excessively upright. Hence he is post-Poitier, but impossible without Poitier. He alone among mainstream black film actors has given us this range with which to think about, and imagine, black men.

Washington has made very precise career choices, and there are no careless moves in his filmography. The first mode is historical, wherein his characters rewrite the historical record that has given black male bravery and accomplishment short shrift. His slave-turned-infantryman in *Glory* updates an archetypal image of slavery when we see him stripped and whipped looking over his shoulder with a single tear running down his cheek, a posture that echoes the iconic engraving of the slave displaying his whipped and lacerated back. To portray black historical characters was the necessary work of the 1980s and 1990s as opportunities for black actors and directors expanded and black people took more control of the image-making onscreen. Even when he did not play title roles, his characters left a strong imprint. Washington's historical films include the 1977 made-for-TV movie, *Wilma,* about track great Wilma Rudolph; *Cry Freedom* (1987), about South African anti-apartheid leader Stephen Biko; the title role in *Malcolm X* (1992); and Rubin Carter in *Hurricane* (1999).

Then there is the military mode: *A Soldier's Story* (1984), *Glory* (1989), *For Queen and Country* (1989), *Liberators: Fighting on Two Fronts in World War Two* (1992), *Crimson Tide* (1995), *Courage Under Fire* (1996), *Antwone Fisher* (2002). His roles range from the ordinary private to the

youngish, Harvard-educated hotshot officer who stops Gene Hackman from blowing up the world in *Crimson Tide,* to the late-middle-aged Navy psychiatrist in his first directorial effort, *Antwone Fisher,* whom he captures with a physical brilliance in his gait of one who has lived in an impeccably fit body for a living and is slightly thickening as he ages, yet maintains ramrod military carriage. Affirmative action actually has made it to the military; within this range of roles Washington has portrayed a cross-section of contemporary black men in specific social contexts.

His roles in the bad-boy mode are perhaps most interesting. I think they provide an escape valve, the antidote to all that Poitier nobility that has cost many black men their lives. The enormous pressure on black men to live up to community expectations while catering to stereotypical expectations and outright racism has resulted in hypertension, asthma, and the other stress-related diseases that befall successful black men at disproportionate rates. When we experience Washington's character Bleek Gilliam's sexuality—and an experience it is—in *Mo' Better Blues* ("It's a dick thing" is how Gilliam explains his multiple sex partners to his faithful lover); *Mississippi Masala* (1991); *He Got Game* (1998); and *Training Day* (2001), Washington seems not to fear the sexual demonization that would come from letting a powerful black male sexuality "speak." For a black actor in a mainstream movie to portray potent, unalloyed black male sexuality that calls no full-blown stereotype to mind is news—good news—indeed.

And then there are the films in which Washington

cannily captures contemporary black men who are largely articulated by their roles in the workplace, a workplace that has changed for black men, the jobs men do rather than the criminals and law enforcement officials that populate most movies: the sharky political operative in *Power* (1986); island gendarme in *The Mighty Quinn* (1989); *Mo' Better Blues* again, where we are shown the work, not just the fruits of the labor, of a jazz musician; the lawyer in *Philadelphia* (1993); the preacher in *The Preacher's Wife* (1996); the semi-employed factory worker/everyman in *John Q* (2002); the football coach who integrates segregated northern Virginia in 1971 in *Remember the Titans* (2002) and says, "I'm not a hero, I'm just a football coach." He plays regular men; yet in that regularity, specifically contemporary and specifically black, there is heroism and, as it has turned out, perceived universality.

I want to take a close look at a film that might not spring to mind first in Washington's formidable canon: *Ricochet*. A close analysis of this movie allows us to get close to the historical specificity and significance of Denzel Washington's work, work that is very much of an era and a time, even when, especially when, Washington selects historical figures to play. He makes everyday characters historical in that his movies that chart the 1980s and 1990s also chart that era. And *Ricochet* deals with one of the most enduringly unresolved racial issues of the last thirty years: affirmative action.

•

Nineteen ninety-one was a year of black men and "boyz" in and out of the hood in African American cinema.

Director/auteur movies such as Mario Van Peebles's *New Jack City*, Kevin Hooks's *Strictly Business*, Matty Rich's *Straight Outta Brooklyn*, Joseph Vasquez's *Hangin' with the Homeboys*, and, of course, John Singleton's hugely successful *Boyz N the Hood* rewrote the black "ghetto" as "'hood" and addressed—both obliquely and at times ham-handedly—matters of urban poverty, drugs and violence, black masculinity, and African American class aspirations and immobility.

That same year saw the release of Russell Mulcahy's *Ricochet*. The director, who is white, walks a distinct and intricate path through the same terrain. I maintain that *Ricochet* constructs a prototypical black bourgeois family of the 1980s "buppy" generation and then dismantles it entirely. *Ricochet* exposes the fundamental fragility of black economic progress, reveals white male antagonism to black male success, and questions the very structure and existence of that filial unit. The role of the buppy patriarch—heterosexual by definition—is constructed and then, in the movie's own language, "deconstructed." *Ricochet* is, then, an anti-affirmative-action parable for the 1990s that is propelled by unfulfilled white male homoerotic desire. As with so many white-authored texts purportedly about the so-called "other," the film is ultimately most revealing as it "deconstructs" the workings of white male anxiety over his own class prerogative—indeed, hegemony—and unrealized sexual wishes, than it is a direct inquiry into buppy patriarchy.

Ricochet bears detailed description. Washington plays a black homeboy-turned-cop-turned-assistant-district-attorney-turned-political-*wunderkind* named Nick Styles.

John Lithgow plays a white criminal named Earl Talbot Blake who becomes obsessed with Styles after their lives intersect the night Styles arrests Blake. The arrest is recorded on amateur video and broadcast on the news, and Styles becomes a politician/media star as his career rapidly advances. Blake's mania leaves him bent on destroying Styles's successful life, a success that Blake feels was won at his expense.

This competitive dynamic is interwoven with an erotic plot. At one point in the film, the two men arm wrestle,[64] and Blake tells his nemesis:

> There we were, both of us at the beginning of our careers, and all of a sudden one of us took off, lit up the sky like a meteor, and why? Because he met the other. I've been following your career. . . . After all that we've meant to each other, this moment here is the first time we've ever touched.

The anxiety that anything a black man might have has been snatched from the rightful grasp of a more-deserving white man is the engine that drives Blake's mania. But he is also, more fundamentally, propelled by sexual desire, for in the entire film Styles's appeal is theatrical, sexual, indeed, pornographic in its reproducibility and commodification. Each of his status transitions are marked by an episode in which he is placed visually center stage, and these moments of theater are almost always captured on videotape. Styles is the object of our ocular desire throughout, no matter who we are. Mulcahy's camera gives us the perspective of straight men (his white

partner), gay men (Blake), straight women (his wife, all manner of reporters and waitresses), and women of ambiguous sexuality (the female district attorney) looking longingly at Styles. When Styles's videotaped escapes are televised, the entire city watches him. So the question of what it means to look directly, unabashedly, and with desire at black men from a number of subject positions is of paramount importance in considering this film. Styles, as Washington plays him, is fully complicit in these seductions; even when he is caught unawares, as in the locker room, he accedes to the gaze, lets himself become a pinup, conducts himself in the mode of the coy centerfold whom the camera simply loves.

Young man on a rapid rise up the capitalist ladder is a storyline that can always be milked for thrills. In *Ricochet*'s fast opening scenes, Styles trades basketball clothes for a police uniform for a dapper suit at a dazzling pace. *Jet* magazine, in its article on *Ricochet*, summarizes the plot in a photo caption: "Everything is going great for Styles and his family, wife Alice and daughter, being blessed by minister, until Blake interferes."[65] This (John) Johnsonian logic pervades the film: wives and daughters are appendages to the image of a black man's career "going great," complete with a preacher's blessing, and it is "the white man," in the person of Blake, who spoils it. This is certainly true in *Ricochet*, but the film also questions (and this is largely accomplished, I think, through Washington's nuanced performance) Styles's own investment in the role, indeed, the myth of the buppy patriarch, an ideology *Jet* is complicit in retaining. The plot then thickens with the addition of taboo black sexuality, embodied by Washington's

particular charm. His smile here is sly, but not reptilian, slick, but not quite greasy. The pun of Styles's name is inescapable in a film as rife with double entendre as this one. In one scene in which Styles is wheeling and dealing in particular glory, Shanice's pop hit "I Like Your Style" can be heard in the background.

There is an illicit element to heterosexual black male business-class success in this country at this time because the only viable models of black male sexuality trafficked in a mainstream economy are variations on outlaws, clowns, and gladiators. But black male financial success and autonomy must be de-fanged for the mainstream to dilute its potential symbolic powers as desirable. The successful character in *Strictly Business,* for example, is a nerd in need of "street" rehabilitation. The patriarchs in *The Cosby Show* and *The Fresh Prince of Bel Air,* while wielding some authority in the family's economy, are nonetheless clownish, overweight *hausfraus* who are dwarfed by their slinky, equally workplace-successful wives. *Ricochet's* Styles is both "gangsta'" and buppy, in increasingly complicated ways as the film progresses.

This is a film with an unusually subtle and detailed understanding of the variegations of class status within African American communities. Across genres, most mainstream portrayals of African American life see only a crudely drawn servant class, a subgroup that is an entertainment class, an outlaw class, and, recently and ever-so-rarely, a professional class. Even within this, vestiges of the other frequently remain. How often must we see black female characters who play college students or lawyers burst into song at some point on the show's run in order to further

their own recording careers? Styles is first identified as a
P.K., or, preacher's kid, and we see that while the pulpit
confers class status on his father's family, it does not offer
class rewards. The public-sector-class success that Styles
earns is different from a more privatized version. And the
family's feeling about Styles's class ascent is crystallized
in a shot of a framed picture of the family on the cover
of the *Ebony*-wanna-be, *Upscale* magazine. On the other
hand, Blake's full name is Earl Talbot Blake, and he is
pale and blond. His name is his title, but because he is
in jail, he is a king without a country. His entitlements
actually grant him nothing at all, and this rage combusts
when a person like Styles—to Blake, all fortune without
entitlement—comes along. *Ricochet,* then, articulates a
complicated class world.

What, then, are black men in the American imagina-
tion? The historic American theater of lynching, revisited
in modern-day terms in the national gaze fixed on George
Holliday's videotape of motorist Rodney King being beaten
by a gang of Los Angeles police officers, has made por-
nographic spectacle of black male bodies being violated.
Think of the public's inability to turn away from mostly
black and Latino men beating each other insensate in the
boxing ring, and of the spectacle of black male bodies
in splendor, in glory, a gladiatorial history of black male
performance, which has always been the grandest of
American spectacles.

However, the containment of the image and its means
of production are necessary in order that white male
desire—specifically, as I am arguing here, for black men—
can be contained and have a safety valve for self-protection

from the unfettered power of black male sexuality. Perhaps this sexuality is no grander or more glorious in and of itself than any other, but it is made magnificent by its sequestering and fetishization. The urban legend of Jesse Helms carrying around one of Robert Mapplethorpe's black male nudes folded up in his back pocket and obsessively unfolding and displaying it to prove his point about the necessity to ban such "obscene" images illustrates my point about the interrelationship of power, desire, containment, and dominion. *Ricochet* is a movie whose camera work asserts that we all want to look at black men, whether we are gay or straight, black or white, male or female. The desire to look is veiled in the trappings of bourgeois success—we "watch" Styles's ascent—but the real reason for looking, no matter who we are, is the sex of it.

•

The opening scene of *Ricochet* takes place on an urban basketball court, in the heat of a game between Nick Styles and his friend Odessa from the neighborhood. The very first words of the film come from Odessa, who taunts Nick, "No competition. No comp," introducing the theme of mano-a-mano class dynamics. The homoerotics of the film are also set into motion from these first sweaty moments, in which the men are literally in each other's faces and the dribbled basketball beats an increasingly manic tattoo to shouted lines such as "I'm taking you right to the hole." From the opening credits, when a bullet is seen zooming from the barrel of a fired gun, *Ricochet* operates in a crudely drawn homoerotic economy. Male couples populate the film: Nick and Odessa, Nick

and his police partner, Larry; Nick and his aide; Blake and Kim. Odessa and Kim are, of course, sexually ambiguous names, and these characters are in many ways the caretaking "wives" in these relationships. Certainly Odessa, when it comes down to it, is more loyal and has more faith in Nick than does his wife, Alice. The script, which is filled with double entendres, is rife with *Moby-Dick* and Trojan jokes, popping balloons and blasting trumpets, and references to "kissing butt" and "assholes" overrun the dialogue. The extraordinary violence of the film is usually impaling.

There is much banter in this scene about whether or not Styles has "left the neighborhood." As this discussion takes place within a sweaty homoerotic world, sex and upward mobility are conflated. Nick's white sidekick from the police force, Larry, has been told to "stop playing like a white boy"; thus, the first white man in the film is constructed as disadvantaged from the start, in terms of physical ability and "cool" that later extend to other perceived disadvantages. In the background, spatially peripheral to the world on the court, are two black women who are the first of many spectators to Nick's prowess. They watch. They smile. They clap.

After the game, the movie is temporalized in the 1980s by Ronald Reagan's voice on the radio in the background. This temporalization is crucial to the understanding of this film as an anti-affirmative-action, Civil Rights–backlash parable. After Nick sees and comments on Odessa's fancy car, we are meant to understand that Odessa is a drug dealer. Nick says to Odessa, through a wire fence, "I guess our playing days are over," and Odessa

replies, "Just on the asphalt, homeboy." There is a heavily double-entendre'd flirtation between Nick and one of the women, Alice, who will become his wife and who is called by her name only once, in the film's second half. This scene telegraphs two key pieces of information: Nick is a "homeboy" on the move who can hang in the hood but whose trajectory points outward to a working world of white men, and women are useful only inasmuch as they remain decorative, marginal, and sexually available according to the whims of the patriarch-to-be.

The next scene segues from the basketball courts to, by implication, the courts that comprise the legal system. Styles and Larry are on duty at a carnival, a world-turned-upside-down in which the thematics of dismantling both an old world order of white male dominion as well as the film's new world order of the ascent of the buppy patriarch are inaugurated. In this scene we first see John Lithgow's character, Earl Talbot Blake, and Kim, his fawning, boy-toy sidekick and, presumably, lover. It is crucial that Kim is dark but not black. As he is Blake's lover, sexual desire for darkness is made literal. But it is also feminized and infantilized so that it exists well within a framework of dominion wherein the older, blonder "man" is in full control. He does not yield to Kim's near-constant adoration. "Tonight's gonna be the night you become a superstar all the way, and I'm gonna see it," Kim exults. The promise of glory is contingent upon its being witnessed. The two are criminals who shoot up fellow criminals in a drug deal gone bad, and Blake and Styles end up in a confrontation that is one of the most startling of the film.

Blake takes a woman hostage, and the terrified crowd

clears, forming a stage for the first of several showdowns between the two protagonists. Styles quickly determines how to outfox his "opponent": he strips down to his underpants and talks fast. A fair-goer with an amateur video camera records Style's striptease. Center-stage, Styles says, "I want you to trust me. I got absolutely nothing on underneath," "I'll be your hostage," and "the only weapon I got left is useless unless you're a pretty girl." Has Styles "read" Blake as a man susceptible to his body and charms? Is he playing to the audience? What is his stake in the seduction? Certainly, he is finding his way out of a deadly situation, but his cool never breaks, and his feline smile suggest great pleasure in the process.

That sly smile is Styles's trademark through the film. It signals to us his investment, and profound sexual pleasure, in his own ascent. Styles calls his penis a "weapon," which is heterosexualized in that it is intended for a "pretty girl," but he delivers the line with a grin that suggests he is fully aware of the homoerotic, pornographic scenario in which he plays. This is coupled with the crude misogyny of Blake's lines about his female hostage: "She's gonna need a paper bag over her head when her boyfriend fucks what's left of her." Women for both of them, though in different ways, are metaphorically useful only inasmuch as they are in some way fuckable. This introduces both themes of surrogacy and sexual rejection. Much later, Blake will lament, "Last time I held a gun in my hand a young man took off all his clothes for me." His only potency is in his weapon, and the only way he can make the man he wants come to him is through force.

Styles shoots Blake in the knee, arrests him, appears on

the news, and becomes not only a hero but a hot commodity. He is summarily promoted by District Attorney Priscilla Brimleigh, who once again plays on the themes of workplace competition with the line, "I'm glad he's too young for my job." Indeed, later, one of her white male underlings says, "I'd like to get her tit in a wringer," and other male colleagues refer to her as "Priscilla the Hun." Brimleigh goes to the police locker room to offer Styles a job, and he is naked, this time, utterly, while all others around him are clothed. His relationship to Brimleigh's gaze, again, is coy. He flits behind a locker but remains ever cool and collected. "Where did you hide it?" Brimleigh asks, referring to the gun in the arrest. Styles holds up his jockstrap and for a split second shows its front—once again, the conflation of the penis with the gun—and then turns to a secret compartment in the back. He is always flirting and always understands that his power and his sexuality are intertwined. Brimleigh says, "From now on I don't want you wearing anything but civvies." He is the D.A.'s commodity, her hot property. The spectre of unjust promotion on the basis of anything other than "merit" is present and undergirds the film's affirmative-action anxiety. Yes, he is being promoted because he has captured a dangerous criminal, but much more so because he is telegenic and appealing; he turns everyone on. Nick has now been explicitly constructed as an object of sexual desire in the eyes of black women, white men, white women, and the viewing audience of both the videotape and the film itself.

The next scenes cut back and forth between Styles and Blake, emphasizing, from Blake's perspective, the utterly

opposite yet interdependent parallelism in their lives. In the prison hospital Blake is tormented by seeing replays of the videotape on television. An elderly man with a tray full of books tries to get him to repent. The books give him an idea, but not the one intended. "I could change a whole life," Blake says, "and it's in my hands." He asks for books, but he does not read them; instead, he tapes them to his leg and begins grueling, rehabilitative exercises. Books are useful for their heft, not for what is inside of them. To have access to books but not to read them suggests a squandered education. The 1978 Supreme Court decision on Alan Bakke, which introduced the term "reverse discrimination" into the American racial lexicon, gave name and support to white male affirmative-action anxieties on campuses. Today, the struggle over affirmative action continues in campuses, workplaces, and the Supreme Court. Blake is also building up his body rather than his storehouse of knowledge with these books, and the body, both inside this film and out of it, has been the stereotypical domain of black men.

From this point on, the scenes switch back and forth between the contrasting lives made parallel of the two men, Nick Styles and Earl Talbot Blake. The black man has two names and one is abbreviated; he is without a resonant etymology in his nomenclature, all "style" and no substance. The white man's three names suggest British nobility. His first name, Earl, becomes his title and cloaks him in a notion of entitlement. Blake, now healed, goes to jail and he replaces his cellmate's male beefcake-bodybuilder pinup with a pinup of his own: Styles.

In prison, Blake cuts out and Xeroxes pictures of

Nick, and as he Xeroxes them, their threat multiplies. The images of Styles suggest the imagined threat of a competitive marketplace overrun by black men. Blake is surrounding himself with multiple images of his object of desire. Meanwhile Styles is swiftly ascending the ladder of socioeconomic success: we see his lovely home, his wife who greets him at the door with a child on her hip, flour on her face, flushed and fuzzed by the kitchen heat but perfectly coiffed when they attend community functions.

In a prison scene, Blake does battle with members of the "Aryan Brotherhood." "When two white men in this prison have a grudge, they settle it like Aryan warriors, one on one, hand to hand," they say, in the self-glorifying language of Reagan-era resurgents such as the Posse Comitatus. Blake armors himself, literally, with books, which he tapes into a shield: the history of the Western world, perhaps, but its lessons unlearned and unread. He battles one of the "Aryans" and the fight climaxes, as it were, when Blake's eye catches a newspaper cutout of Styles on his opponent's armor. He drives his sword through the photograph and the living man beneath. Kim says, "These guys are pussies, but you, you're the true Aryan." Blake lets Kim in on his plan to "destroy" Styles's "life," to which Kim will later exult: "What's art is how you single-handedly deconstructed Nick Styles's life ... that's art ... that's the Sistine Chapel." After this prison battle, Blake's plot to "deconstruct" the life of Nick Styles is in full swing. Styles is a nemesis, who has what Blake thinks is his own birthright: a life of public ascent and upper-middle-class success.

Every scene with Styles highlights his theatricality, as well as his theatricalization. He prosecutes a "night strangler" with seduction and flash. The white male attorney on the opposing side crumples up his notes in disgust, and we are meant to be uncertain as to whether Styles won over the jury by brains or theatrics. He argues with his jacket off, giving the appearance of ease and spontaneity as well as, in the anti-affirmative-action mindset in the scene, a lack of professionalism and preparation. Styles goes to the crackhouse run by Odessa to plead for safety surrounding the community center he hopes to build, and the crackheads stop smoking the pipe to gather around and listen to him preach.

Styles's black aide is introduced and the film gains yet another male coupling that is more important to Styles than his nuclear family. The aide is the one who will help his career ascend. After Blake has, predictably, busted loose from jail in order to activate his anti-Styles vendetta (and he escapes after a parole hearing in which the language of "the disadvantaged" is employed to try to free him), he kills the aide but makes it look like the aide has hanged himself. Blake dresses the aide in leather drag, puts child pornography in his briefcase, and makes it appear that the aide and Styles embezzled money and abused young boys. The last time the aide sees Styles, he says, "Washington, here we come." Black men, then, are punished both for aiming too high as well as for believing their own hype. The movie's message is, no matter what kind of accomplished life one lives, it can be tarnished and taken apart after death, in a second. Black men's accomplishments are never "real" or truly earned. Styles

receives the news of his aide's death in the middle of making love to his wife. The heterosexual family narrative is interrupted not only by the sphere of work but by the taint of scandal both present and imminent.

Styles's house—the heterosexual domestic sphere—is set up as an inviolate sanctum. Alice is careful to ask, "Who is it?" even when it is her husband at the door. She opens it and he goes inside, but the camera does not follow them; the door is shut. But when Blake is on the loose and comes to the house posing as a power repairmen, the white baby-sitter opens the door without even asking. She tells the children he is "The Power Man," thus instructing them in the ways of white male hegemony. The camera follows him into the house, where he drugs the baby-sitter, and eventually follows him up the stairs carrying the two little girls. He has full reign of the house, and when he adjusts a crooked picture on the wall—the framed *Upscale* cover—it is as though to say, your family is all image, all sham, and I have control over that; I can right the picture just as I can "deconstruct" your life. When Styles and his wife return, the baby-sitter awakens from her drugged stupor and dreamily murmurs, "The power guy was here."

Styles is kidnapped in front of his home by Blake and Kim, drugged, and forced into sex with a white, blond prostitute who gives him gonorrhea. During the kidnapping, the men arm wrestle in the scene discussed earlier. Styles uses the language of affirmative action and desire. Styles wins the first round, slamming Blake's hand to the ground; he has won fair and square, brawn to brawn, and he crows, "You lose." But Blake retorts, "No, you lose!"

Kim injects Styles with drugs and Blake slams down his hand. The proverbial playing field is not level; the white man needs drugs and an accomplice to come out ahead, but he insists on behaving as though the game is fair. Styles asks, "You killed my life. Are you going to kill me?" and Blake replies, "No, I'm going to do something far worse. I'm going to let you live." The successful black man's life becomes a complete construction, an entity other than the lived life, a fiction that is inhabited with varying degrees of success.

Styles is dumped unceremoniously in front of City Hall, where he is pulled awake by a worker rounding up homeless people. No one believes he was set up, since Blake, after all, is thought to be dead. When Styles tells his wife, "He's trying to make me look crazy," she replies, "Well, I hate to tell you, honey, it's working." To be addressed as "honey" invokes familial language, even in the face of such an utter lack of faith. The only ones who do believe him are his partner Larry and his homeboy Odessa, reinforcing the way in which the heterosexual family is taken apart while the homosocial bonds remain inviolable. The most loyal families in this film, and the ones who get the most screen time, are the unarticulated "families" of male couples. At Styles's behest, Odessa takes Alice and the children to a haven in the hood; they are safer in the crackhouse than they are in their own house.

Styles stages his vindication against Blake and beats him at his own game; Blake ends up impaled on a spire of the very tower that will be the site of Styles's youth center, which is also the site of the crackhouse. When Styles thanks Odessa, he says he will see him that weekend,

back on the court. He kisses his wife and is once again the buppy patriarch, but he has learned that you can't flee too far from your roots, or your "wife," in the hood. At the very end of the film, after his final victory, Styles says into the camera, "Are we on the air?" When the answer is affirmative, he says, "Then you can kiss my black ass," and the video clicks off.

•

It is instructive to juxtapose two definitions of the male buddy film, the genre that *Ricochet* plays with and subverts. First, from Joel Silver, who produced this film as well as *Lethal Weapon* and *48 Hours,* which also featured black-white pairs:

> [I]n most action films which revolve around the team of two men, you're introduced to two guys who hate each other, are forced to work together, and by the end of the film, learn to like each other. What fascinated me about the premise of *Ricochet* was that you started with two guys who hated each other. They get separated and when they come together again, they hate each other even more. Their hatred is as much of a bond between them as the friendship between the guys in the other movies. You might call *Ricochet* an "anti-buddy" movie.[66]

Critic Richard Dyer sees those films another way:

> The buddy movie presented a male-male relationship that was composed of humour, tacit

> understanding and, usually, equality of toughness
> between men. This relationship was constructed
> by a disavowal of the very thing that would
> appear to bind the men together—love. The
> elements that compose the relationship actually
> effect this disavowal—badinage as a way of not
> expressing serious emotions, silent communica-
> tion as a means for not articulating or confront-
> ing feelings, toughness as a sign that one is above
> tenderness. . . . A further feature of the buddy
> movie's representation of male-male relation-
> ships is its explicit denial of homosexuality.[67]

Dyer identifies the very thing that Silver so rigorously avoids: homosexual attraction that the genre subsumes in "badinage" and "toughness between men." In interracial buddy movies, race, too, is disarticulated in this fashion. Perhaps *Ricochet* is neither "buddy" nor "anti-buddy" but rather, "I want to be your buddy," which is, in this case, a version of "I want to be you," or, "I want what you have," or, "I don't want to be me." For the missing scene in *Ricochet* would have Blake actually consummating his desire and sodomizing Styles. Which does he want to do more, rape and destroy him, or make love to him? His extraordinary rage is part and parcel of his sexual desire.

Along with Blake, the audience has been set up as spectators to Nick's near-naked body, black and splendid. That is precisely why the family must be destroyed: it in-terferes with the sexual desires of Blake, desires in which the audience has been made complicit. Blake has melded desire with dominion; indeed, the history of domination walks hand in hand with sexual desire. Because we do not

see a sex scene with Styles, Blake's character can be read as both literally and metaphorically impotent, only able to have sex through videotaped surrogacy with a drugged and kidnapped lover. He is impotent, furthermore, in the very face and presence of black male prowess, both mythical and real.

In a *Washington Post* article called "'Boyz' and the Breakthrough: The Violent Birth of Hip-Hop Cinema," conservative commentator Cal Thomas asserted that movies such as Singleton's *(Boyz N the Hood)* are dangerous: "During the '70s, we had *Shaft* and all of those movies, and *Soul Train* and all the rest. . . . But it portrays an underside of the black experience that is not, in my judgment, promoting future Clarence Thomases." The interviewer asks, "Wait a minute, *Soul Train?*" and Cal Thomas replies, "Yeah, the heavy sexual orientation of the body rhythms."[68]

Here I think about courts, about what that frame ritualizes. What is the space of the basketball court, of black male theatrics in the white male imagination? In *White Men Can't Jump,* the basketball court is imagined as a classless, raceless, hyper-gendered space of transcendence. It is also, crucially, where white men can safely articulate and experience their desire for black men. In the courtroom, conversely, an arena of economic competition and social justice, that desire becomes a threat to what the white man believes is his. He cannot be a spectator or consumer because his own livelihood and public masculinity are at stake. For white patriarchal supremacy has always worked within a conceptual framework of

relativity. If there is no other to conquer, what is there left of the self?

And what of the "self" of the Nick Styleses of the world who too-willingly believe the hype of buppy success, of patriarchal dominion, as a way out of the de-limiting cage that is black manhood in the mainstream imaginary? Does the fact that the director Mulcahy is white mean that we can dismiss what Styles represents in spite of the misdoings of "the man"? *Ricochet*'s version of black manhood and male success is not too far from the slick, surface mythology of black bourgeois manhood that is propounded not only by the black press but in a black public sphere that insists on advocating a patriarchal model of leadership in which the black public is cast as the credulous wife and children of a nuclear, patriarchal family. *Ricochet* marks alternative contours of family loyalty—homosocial bonding between men—flagrant but silent in the nuclear model I have described.

I do not wish to veer completely from what I have described as the most pressing dynamic of the film: the linkage of desire and dominion that frequently propels white male anxiety and consequent abuses of power against black men. The historical and present might of this dynamic must never be underestimated. However, perhaps the movie can lead us to an intra-community questioning of another order: How does a fear of the complexities of one's own desires, as well as conservative, upwardly mobile black family discourse, truncate imagining other forms of family and community? Where is a model of black male sexuality and self-pleasure that can

narrate itself without a concurrent narrative of dominion, which apes the very system it abhors? Racial progress without feminism and class awareness is a dead-end. And, finally, simply, how might we vision a black masculinity that resists the lure of the myth of buppy patriarchy?

"CAN YOU BE BLACK
AND LOOK AT THIS?": READING
THE RODNEY KING VIDEO(S)

◆

I still carry it with me all the time. I prayed
for years for it to be taken away, not to be able
to remember it.

BETTY SHABAZZ, ON SEEING
MALCOLM X'S MURDER[69]

Memory resides nowhere, and in every cell.

SAUL SCHANBERG, DUKE UNIVERSITY
MEDICAL RESEARCHER[70]

1.

At the heart of this essay is a desire to find a language to
talk about "my people." "My people" is, of course, roman-
tic language, but I keep returning to it as I think about the
videotaped police beating of Rodney King, wanting the
term to reflect the understanding that "race" is a complex
fiction but one that, needless to say, is perfectly real in at
least some significant aspects of our day-to-day lives.

There is no satisfactory terminology in current use adequate to represent how I am describing a knowledge and sense of African American group identification that is more expansive than the inevitable biological reductions of "race" and the artifactual constraints of "culture." What do black people say to each other to describe their relationship to their racial group, when that relationship is crucially forged by incidents of physical and psychic violence that boil down to the "fact" of abject blackness? Put another way, how does an incident like King's 1991 beating consolidate group affiliations by making blackness an unavoidable, irreducible sign that, despite its abjection, leaves creative space for group self-definition and self-knowledge?

The colloquial adoption of "tribe" seemed for a time to speak to a history and group identification that is claimed rather than merely received, and theorized by the people in that group. "Tribe" seemed to speak to the group recognition and knowledge that arose as a functional aspect of the originary rupture of the Middle Passage, which gave birth to the African American in all the violent and blank possibility of the hyphen, the slash. It seemed to get at the way in which a group organizes memory in a way that was useful to the project here of naming the ghostly or ancestral aspect of memory that vitalizes everyday life. But "tribe" carried with it a history of usage that erased difference and erected limiting, patronizing ethnic constructs, and this history eclipsed my attempt to reclaim derogatory usage.[71]

The stories of violence and subsequent responsive group knowledge and strategy compel us even as we hold

on to the understanding of profound differences between African Americans. This essay considers the inchoate way in which black people might understand themselves to be part of a larger group. More than I mean "political," "ethnic," "subcultural," "diasporic," I am talking about what it is to think of oneself, in this day and age, as having "a people."

Black bodies[72] in pain for public consumption have been an American national spectacle for centuries. This history moves from public rapes, beatings, and lynchings to the gladiatorial arenas of basketball and boxing. In the 1990s in particular, African American bodies on videotape were the site on which national trauma—sexual harassment, "date rape," drug abuse, racial and economic urban conflict, AIDS—was dramatized. I refer to the cases of former Washington, D.C. Mayor Marion Barry's videotaped crack-smoking and subsequent arrest; the Clarence Thomas Senate hearings; Mike Tyson's rape trial; Magic Johnson and Arthur Ashe's televised press conferences about their HIV and AIDS status; and, of course, the Rodney King beating. In each of these traumatic instances, black bodies and their attendant dramas are publicly "consumed" by the larger populace. White men have been the primary stagers and consumers of the historical spectacles I have mentioned, but in one way or another, black people have been looking, too, forging a traumatized collective historical memory that is reinvoked, I believe, at contemporary sites of conflict.[73]

What collective versions of African American male bodily history do different groups of viewers, then, bring to George Holliday's 81-second videotape of Rodney

King being beaten by 4 white Los Angeles police officers while a crowd of other officers watches? When these officers were first put on trial in Simi Valley, and when the jury came back with its "not guilty" verdicts, what metaphorizations of the black male body were in place that called upon a constructed national historical memory, a code in which African Americans are nonetheless perfectly literate?

By presenting an archive of a series of cases, I articulate the ways in which a practical memory exists and crucially informs African Americans about the lived realities of how violence and its potential affects our understanding of our individual selves as a larger group. The Court TV–produced videotaped condensation of the first, Simi Valley trial[74] reveals the ways in which freeze-framing distorted and dehistoricized the narrative logic of the beating. The videotaped trial also displays how a language of black male bestiality and hyper-virility, along with myths of drug abuse and "superhuman strength," were deployed during the trial. King was described as a "buffed-out" "probable ex-con"; "bear-like," "like a wounded animal," "aggressive," "combative," and "equate[d] . . . with a monster." Closing defense statements continually named a "we," in a construction dependent upon the non-black composition of the Simi Valley jury. Attorney Michael Stone, speaking of L.A.P.D. officers, concluded with, "They don't get paid to roll around in the dirt with the likes of Rodney King." These sensationalist codes erased Rodney King's individual bodily history within the event itself and supplanted it with a myth of white male victimization: hence the statement by Sergeant Stacy Koon's

lawyer that "there's only one person who's in charge of this situation and that's Rodney Glenn King."

The narrative space between the nationally televised videotape and the Court TV version opens an avenue to think about what various national imaginations—primarily racially determined but also marked by region, class, gender—bring to the viewing of this episode. It also reveals how bodily experience—both individually experienced bodily trauma as well as collective cultural trauma—becomes a form of memory reactivated and articulated at moments of collective spectatorship.

In these anti-essentialist, post-identity discursive times, I nonetheless believe that different groups possess sometimes-subconscious collective memories, which are frequently forged and maintained through a "storytelling tradition," however difficult that may be to pin down, as well as through individual experience. When a black man in Florida can be set on fire amid racial epithets in the street because he inhabits a black body, or dragged to his death down Texas highways tied to the back of a car, there must be a place for theorizing black bodily experience into the larger, ever-evolving discourses of identity politics.

If any one aphorism can characterize the experience of black people in this country, it might be that the white-authored national narrative deliberately contradicts the histories our bodies know. There have always been narratives to justify the barbaric practices of slavery and lynching. African Americans have always existed in a counter-citizen relationship to the law; how else to contend with knowing oneself as a whole human being when the Constitution defines you as "three-fifths"? The

American way with regard to the actual lived experience of African Americans has been to write a counternarrative, where needed, that erased bodily information as we knew it and substituted a counter-text which has, in many cases, become a version of national memory.

Some sympathetic white colleagues discussing the King beating anxiously exempted themselves from the category of oppressor even when they had not been placed there by saying that they too were nauseated and traumatized by watching what happened. This is no doubt true, but that is not my interest here. The far more potent terrain is the one that allows us to explore the ways in which traumatized African American viewers have been taught a sorry lesson of their continual, physical vulnerability in the United States that concurrently helps shape how it is we understand ourselves as a "we," even when that "we" is various. The King beating, and the anguished court cases and insurrections that followed, reminded us that there is such a thing as "bottom line blackness" with regard to violence that erases differentiations and highlights race.

Two other "cases" help describe the way the Rodney King videotape was experienced as an aftershock, an event in an open series of national events: nineteenth-century slave accounts of witnessed violence, and the 1955 lynching of Emmett Till. These cases demonstrate how, to use the Biblical phrase James Baldwin has already deployed, "the evidence of things not seen" is crucial to understanding what African American spectators bring to the all-too-visible texts at hand of spectacular slave violence and the story of a brutalized Emmett Till.

2. "A WITNESS AND A PARTICIPANT"

What do the scenes of communally witnessed violence in slave narratives tell us about the way that "text" is carried in African American flesh? Witnessing can be aural as well as visual. Further, those who receive stories become witnesses once removed, but witnesses nonetheless. Frederick Douglass, in his 1845 narrative, recalls watching a beating at the hands of his first "master," Captain Anthony:

> He would at times seem to take great pleasure in whipping a slave. I have often been awakened at the dawn of day by the most heart-rending shrieks of an own aunt of mine, whom he used to tie up to a joist, and whip upon her naked back till she was literally covered with blood. No words, no tears, no prayers, from his gory victim, seemed to move his iron heart from its bloody purpose. The louder she screamed, the harder he whipped; and where the blood ran fastest, there he whipped longest. He would whip her to make her scream, and whip her to make her hush; and not until overcome by fatigue, would he cease to swing the blood-clotted cowskin. I remember the first time I ever witnessed this horrible exhibition. I was quite a child, but I well remember it. I never shall forget it whilst I remember any thing. It was the first of a long series of such outrages, of which I was doomed to be a witness and a participant. It struck me with awful force. It was the blood-stained gate, the entrance to the hell of slavery, through which I was about to pass. It was

a most terrible spectacle. I wish I could commit
to paper the feelings with which I beheld it.[75]

Douglass's repetition of "he whipped" and its variations
replicates the falling of the awful blows. The staccato,
structurally unvaried, repetitive sentences toward the
end of the passage, in contrast to the liquid syntax of
other parts of the book, reveal Douglass increasingly at
a loss for words to describe what he has beheld. More
specifically, he can scarcely articulate what it means
for that visual narrative to become forever a part of his
consciousness. Yet what linguistically knits this passage
together at its close is the phrase "I remember," repeated
three times. Douglass feels "doomed to be both a wit-
ness and a participant." The tableau "struck" him with the
same "awful force" of the blows. At the passage's close, he
experiences a birthing of sorts as he travels through the
"blood-stained gate," his body brought into the realization
of itself as vulnerable and black.

On the next page, Douglass describes his aunt Hester
being whipped:

> [A]fter rolling up his sleeves, he commenced to
> lay on the heavy cowskin, and soon the warm, red
> blood (amid heart-rending shrieks from her, and
> horrid oaths from him) came dripping to the floor.
> I was so terrified and horror-stricken at the sight,
> that I hid myself in a closet, and dared not venture
> out till long after the bloody transaction was over.
> I expected it would be my turn next. It was all new
> to me. I had never seen any thing like it before.

One, of course, cannot *see* that blood runs "warm"; Douglass's synaesthetic response is instantly empathetic, and the memory is recorded in a vocabulary of known bodily sensation. He imbibes the experience, which is metaphorically imprinted upon his now traumatized flesh in the shrieks experienced as "heart-rending" and that left him "horror-stricken." The mere sound of the voice of the overseer, who in the previous sentence Douglass has described as "whip[ping] a woman, causing the blood to run a half hour at a time," is "enough to chill the blood and stiffen the hair of an ordinary man." Once again, these corporeal images of terror suggest that "experience" can be taken into the body via witnessing and recorded as knowledge. This knowledge is necessary to someone who believed "it would be my turn next." The knowledge of that violence and his vulnerability to it is, paradoxically, the armor that can take Douglass out of the closet in which he has hidden but which he must inevitably leave. For if nothing else, the horrors of slavery were not longer "new" to him; from this point in the text forward, he would figure his way out of that institution.

In Harriet Jacobs's *Incidents in the Life of a Slave Girl*, protagonist Linda Brent's response to witnessed violence contrasts sharply with the response of white spectators.[76] Brent's mistress Mrs. Flint, for example, "could sit in her easy chair and see a woman whipped, till the blood trickled from every stroke of the lash." But when Brent watches a fellow slave tied to a joist and whipped, she says, "I shall never forget that night. Never before, in my life, had I heard hundreds of blows fall, in succession, on

a human being. His piteous groans, and his 'O, pray don't, massa,' rang in my ear for months afterwards."

Hearing, too, is central to witnessing. Heard images haunt the mind as much as visual ones. In this regard, the freeze-framed Simi Valley videotape, stripped of a soundtrack in which falling blows and bystanders' screams are audible, disallows the possibility that heard terror could imprint itself on the jury's mind. When Brent sees someone sold away from his mother—not violence, per se, but torture nonetheless—she writes, "Could you have seen that mother clinging to her child, when they fastened the irons upon his wrists; could you have heard the heart-rending groans, and seen her bloodshot eyes wander wildly from face to face, vainly pleading for mercy; could you have witnessed that scene as I saw it, you would exclaim, *Slavery is damnable!*" As with Douglass, "heart-rending" and "bloodshot" work both literally and metaphorically to show the ways the body has a language that "speaks" what it has witnessed. Brent speaks here to white women readers, exhorting them to reject Mrs. Flint's subject position and assume instead her own, the position of one who witnesses rather then simply watches.

In the autobiographical *The History of Mary Prince*, witnessed violence is quickly followed in the narrative by violence to Prince herself. What happens to another, she understands, places her under threat:

> Both my master and mistress seemed to think
> that they had a right to ill-use [the slave boys] at
> their pleasure; and very often accompanied their
> commands with blows, whether the children

were behaving well or ill. I have seen their flesh
ragged and raw with licks. —Lick—lick—they
were never secure one moment from a blow, and
their lives were passed in continual fear. My mis-
tress was not contented with using the whip, but
often pinched their cheeks and arms in the most
cruel manner. My pity for these poor boys was
soon transferred to myself; for I was licked, and
flogged, and pinched by her pitiless fingers in the
neck and arms, exactly as they were. To strip me
naked—to hang me up by the wrists and lay my
flesh open with the cow-skin, was an ordinary
punishment for even a slight offence.[77]

"Pity" for the boys is "transferred" to Prince herself. She
understands her safety is at stake if theirs is. The repeti-
tion here of variations on "lick" again recalls the mimetic
effect seen in the Douglass passage, but also emphasizes
Prince's artifice in constructing the violent spectacle. The
narrative time of the event is slowed down, knit together
with homophonic words like "ill," "pinched," "pity," "piti-
less," "fingers," "strip," and "wrist," and framed. Prince art-
fully makes a stylized tableau that her readers can more
empathically experience.

 Prince then watches a pregnant woman, Hetty, whipped
over and over again:

The consequence was that poor Hetty was
brought to bed before her time, and was deliv-
ered after severe labour of a dead child. She ap-
peared to recover after her confinement, so far
that she was repeatedly flogged by both master

and mistress afterwards; but her former strength
never returned to her. Ere long her body and
limbs swelled to a great size; and she lay on a mat
in the kitchen, till the water burst out of her body
and she died. All the slaves said that death was a
good thing for poor Hetty; but I cried very much
for her death. The manner of it filled me with
horror. I could not bear to think about it; yet it
was always present to my mind for many a day.

After this litany, you might say, of course these historic
scenes of horror would stay forever with those who saw
them, knowing as they did that their fate was bound up in
a system of domination and violence to bodies as well as
memory. But I am building a case for a collective memory
that rests in the present moment, which was activated by
watching the King videotape (and subsequent publicized
acts of violence) and has been constructed as much by
storytelling in multiple media as by personal, actual expe-
rience. The conundrum of being unable to "bear to think
about" something that is "always present to my mind" is
precisely that legacy of state-sanctioned violence against
African Americans. On the one hand, to see is unbear-
able, both unto itself as well as for what it means about
one's own likely fate. But the knowledge of this pervasive
violence provides necessary information of the very real
forces that threaten African Americans. In the absence
of first-person witnessing, the stories are passed along
so that everyone knows the parameters in which their
bodies move.

These responses of poor and working-class Angelenos of color to the Rodney King videotape augment this point. Rodney King was beaten by officers of the Los Angeles Police Department who specifically embody the state as experienced in the day-to-day lives of the people who made these three statements reported in the *Revolutionary Worker* newspaper:

> You know where I was when I first heard about the verdict? I was laying down in my bed asleep and when I heard the words not guilty on my TV I instantly woke up. It was a pain that went from the top of my head to the tip of my toes. It was an empty, hollow feeling. It was a rage inside of me, burning. I wanted to kill. I wanted to kill.

> By the time they was done I needed 28 stitches in my head. When I saw the Rodney King video I thought of myself laying on the ground and getting beat. I felt the same way all our people felt when we blew up.

> Somebody brought a video to school—the video of Rodney King—and then somebody put it on the television and then everybody just started to break windows and everything—then some people got so mad they broke the television.[78]

Again, the violence that is watched, this time on the television, is experienced, as it were, in the bodies of the spectators who feel themselves implicated in Rodney

King's fate. The language employed by the first speaker is a corporeal one, "heard" and then experienced in his nervous system as "a pain that went from the top of my head to the tip of my toes." The entire body and its synapses make this response. More dramatically, the second speaker abandons simile and speaks without the intermediary of "like" or "as." He "needed 28 stitches" and felt himself "laying on the ground and getting beat." The third speaker is the one who draws the link between a sense of collective violation and consequent physical response. The video is seen in school, a community, and that community acts without hesitation and, according to this account, in tandem and agreement that a violation has taken place.

Hortense Spillers writes: "These undecipherable markings on the captive body render a kind of hieroglyphics of the flesh whose severe disjunctures come to be hidden to the cultural seeing by skin color. We might well ask if this phenomenon of marking and branding actually 'transfers' from one generation to another, finding its various *symbolic substitutions* in an efficacy of meanings that repeat the initiating moments?"[79] Haile Gerima's film *Sankofa* asks audiences to regard the connections between an African American present, an African past, and the space of slavery between. A persistent motif of the film's plantation scenes is the eyes that watch black comrades being beaten, raped, terrorized, killed. Little is said in these scenes in which the violent legacy is passed along, but Gerima's camera sees eyes everywhere: eyes watching in eloquent, legible witness.

3. EMMETT TILL

. . . the avid insistence of detail
pretending insight or information
the length of gash across the dead boy's loins
his grieving mother's lamentation
the severed lips, how many burns
his gouged out eyes
sewed shut upon the screaming covers
louder than life
all over
the veiled warning, the secret relish
of a black child's mutilated body.

AUDRE LORDE, "AFTERIMAGES"[80]

Here is the story in summary: In August 1955, in Money, Mississippi, a fourteen-year-old Chicago black boy named Emmett Till, nicknamed "Bobo," was visiting relatives and was shot in the head and thrown in the river with a mammoth cotton gin fan[81] tied around his neck, for allegedly whistling at a white woman. In some versions of the story, he was found with his cut-off penis stuffed in his mouth. His body was shipped to Chicago and his mother decided he should have an open casket funeral; the whole world would see what had been done to her son. According to the Chicago-based, black news weekly *Jet*, "more than 600,000, in an unending procession, later viewed the body at the funeral home."[82] A photograph of Till in the casket—his head mottled and swollen to many times its normal size—ran in *Jet*, and largely through that

medium, both the picture and Till's story became legendary. The caption of the close-up photograph of Till's face read: "Mutilated face of victim was left unretouched by mortician at the mother's request. She said she wanted 'all the world' to witness the atrocity."

Emmett Till's story has inspired entire works such as Bebe Moore Campbell's *Your Blues Ain't Like Mine*, Toni Morrison's play, *Dreaming Emmett*, Gwendolyn Brooks's famous pair of poems, "A Bronzeville Mother Loiters in Mississippi. Meanwhile, a Mississippi Mother Burns Bacon" and "The Last Quatrain of the Ballad of Emmett Till," and "Afterimages": Audre Lorde's poem, quoted above, and many more. The lasting impact of the photograph and the story is also illustrated in several autobiographical accounts.[83] In Anne Moody's memoir, *Coming of Age in Mississippi*, she writes:

> Up until his death, I had heard of Negroes found floating in a river or dead somewhere with their bodies riddled with bullets. But I didn't know the mystery behind these killings then. I remember once when I was only seven I heard Mama and one of my aunts talking about some Negro who had been beaten to death. "Just like them low-down skunks killed him they will do the same to us."[84]

Charlayne Hunter-Gault remembers the killing in her autobiography, *In My Place*:

> From time to time, things happened that intruded on our protected reality. The murder of Emmett

Till was one such instance. It happened in
August 1955, and maybe because he was more or
less our age, it gripped us in a way that perhaps
even the lynching of an older Black man might
not have. "It was the first time we'd known a
young person to die," recalled Wilma, who, like
me, was then entering eighth grade. For both of
us, pictures of his limp, watersoaked body in the
newspapers and in *Jet*, Black America's weekly
news bible, were worse than any image we had
ever seen outside of a horror movie. . . . None of
us could ever forget the haunting gray image of
the dead and waterlogged young boy; we just put
it on hold."[85]

Shelby Steele writes of the murder in an autobiographi-
cal essay that became part of his memoir, *The Content of
Our Character*:

The single story that sat atop the pinnacle of
racial victimization for us was that of Emmett
Till, the Northern black teenager who, on a visit
to the South in 1955, was killed and grotesquely
mutilated for supposedly looking at or whis-
tling at (we were never sure which, though we
argued the point endlessly) a white woman. Oh,
how we probed his story, finding in his youth
and Northern upbringing the quintessential
embodiment of black innocence, brought down
by a white evil so portentous and apocalyptic, so
gnarled and hideous, that it left us with a feeling
not far from awe. By telling his story and others

like it, we came to *feel* the immutability of our
victimization, its utter indigenousness, as a thing
on this earth like dirt or sand or water.[86]

For black writers of a certain age, and, perhaps, of a certain proximity to Southern roots, Emmett Till's story is the touchstone, a rite of passage that indoctrinated these young people into understanding the vulnerability of their own black bodies, and the way in which their fate was interchangeable with that of Till. It also was a step in the consolidation of their understanding of themselves as black in America. It is in this regard that black women have taken the story to be emblematic, though Till's fate was carried out in the name of stereotypical black male sexuality. These passages show how storytelling creates collective counter-memory of trauma as those same stories also terrorize.

In Muhammad Ali's autobiography *The Greatest*, Till's murder is a formative touchstone of young Cassius Clay's adolescence:

> I couldn't get Emmett out of my mind, until
> one evening I thought of a way to get back at
> white people for his death. That night I sneaked
> out of the house and walked down to Ronnie
> King's and told him my plan. It was late at night
> when we reached the old railroad station on
> Louisville's West Side. I remember a poster of
> a thin white man in striped pants and a top hat
> who pointed at us above the words UNCLE
> SAM WANTS YOU. We stopped and hurled
> stones at it, and then broke into the shoeshine

boy's shed and stole two iron shoe rests and
took them to the railroad track. We planted
them deep on the tracks and waited. When a
big blue diesel engine came around the bend, it
hit the shoe rests and pushed them nearly thirty
feet before one of the wheels locked and sprang
from the track. I remember the loud sound of
the ties ripping up. I broke out running, Ronnie
behind me, and then I looked back. I'll never
forget the eyes of the man in the poster, staring at
us: UNCLE SAM WANTS YOU. It took two
days to get up enough nerve to go back there. A
work crew was still cleaning up the debris. And
the man in the poster was still pointing. I always
knew that sooner or later he would confront me,
and I would confront him.[87]

Seeing the picture of the dead boy's ruined body makes
young Cassius feel "a deep kinship." He and his father
"dramatize the crime," which, like the young people
quoted in the *Revolutionary Worker* who saw the King
tape in school and smashed the television, becomes a
catalyst for action. The train symbolizes commerce and
technology, the unrealized dreams of black migration
north as well as the reverse migration south, which got
Till killed. Clay responds not with the legendary pul-
chritude of his bare, magnificent body, but rather with
stone—a tool from nature—and the iron shoe rests. In
destroying the shoeshine rests he destroys a hardy symbol
of black servitude. The black shoeshine "boy" and all it
stands for is symbolically extinguished. Clay undercuts
his physical might, the mythology of Frederick Douglass

ultimately whipping the white overseer Covey, acknowledging that no black male body alone can triumph over consolidated white male might. The hovering UNCLE SAM WANTS YOU poster allows Clay to articulate through this incident a relationship between himself and state power.

We remember Till because of all his story emblemizes, and because of what was burned into our nightmares and imaginations with the photograph. Till's body was ruined but nonetheless remained a body, with outlines that mean it can be imagined as kin to, but nonetheless distinct from, our own. American narratives of violence against blacks in the popular imagination are usually figured as male. The whipped male slave, the lynched man, Emmett Till, Rodney King: all of these are familiar and explicit in the popular imagination. Because black men present a particular kind of physical threat in the white American imagination, that threat must be contained. Countless stories of violence were made spectacular to let black people know who was in control, such as when Louisiana Ku Klux Klansmen in the 1940s would tie the bodies of lynched black men to the fronts of their cars and drive them through crowds of black children.[88] So black men are contained when these images are made public, at the very same time that black viewers are taking in evidence that provide ground for collective identification with trauma. These Emmett Till narratives illustrate how black people have paradoxically had to witness their own murder and defilement in order to survive and then to pass along this epic tale of violation.

4. RODNEY KING

Outside the door of no return, our arms linked
from habit, a vendor spies the pain. Don't
cry, he says. It wasn't you or me. It's just
history. It's all over.

<div align="center">EISA DAVIS[89]</div>

An article in the 2 February 1993 *New York Times* de-
scribed life for the four police L.A.P.D. officers as they
awaited their second trial, after being acquitted in the
Simi Valley trial of violating Rodney King.[90] Sergeant
Stacy Koon, who was "in charge" on the night of the
beating, says he has just been declared "psychologically
disabled" for work and gives a laundry list of physical
disorders he says have plagued him since the incident:
trouble sleeping, "stomach problems," "high blood pres-
sure," and teeth grinding. His days are now spent poring
over some 17,000 pages of trial testimony and watching,
over and over and over again, the tape of the beating, on
a big-screen TV in his living room. He takes the tape
on speaking tours, he projects it on different walls at his
home, he demands that visitors watch it, and hear his nar-
rative overlay of the event:

> There's 82 seconds of use of force on this tape,
> and there's thirty frames per second. There's
> like 2,500 frames on this tape and I've looked at
> every single one of them not once but a buzillion
> times, and the more I look at the tape the more

I see in it. . . . When I started playing this tape,
and I started blowing it up to ten inches, like I'd
blow it up on the wall right behind you here, fill
up the whole wall over the stairwell, and all of
a sudden, this thing came to life! You blow it up
to full size for people, or even half size, if you
see Rodney King four feet tall in that picture
as opposed to three inches, boy, you see a whole
bunch of stuff. . . . He's like a bobo doll. Ever
hit one? Comes back and forth, back and forth.
That's exactly what he's doing. Get him down on
the ground. Prone is safe. Up is not. That is what
we're trying to do is keep him on the ground, be-
cause if he gets up it's going to be a deadly force
situation. . . . This [new trial] is going to be fun.
This is high comedy.

Koon creates a narrative to "justify" his dominion, and
the more he watches it, the more he believes it. He is
able to watch, over and over, larger and larger, and appar-
ently does not see himself physically magnified as King
is magnified. For different reasons, in these moments of
collective trauma, to use the words of the visual artist
Adrian Piper, white and black spectators "pretend not to
know what . . . [they] know,"[91] both for self-justification
and psychic survival. There were many narratives, then,
created to describe the same 81 seconds of videotape, and
infinite amounts of energy and cultural memory were
expended to preserve each version of the truth.

The concept of videotaped national memory was
crucial to the Rodney King beating and the subsequent
Los Angeles riot/insurrection. Videotaped footage of

black teenager Latasha Harlins being shot to death by a Korean shopkeeper preceded King; white motorist Reginald Denny being pulled from his truck and beaten by several African American men during the disturbances formed the other video bookend. The videotape of Desiree Washington dancing in her beauty pageant the day after she was raped by Mike Tyson was used to attempt to prove that she could not possibly have been violated. Videotape imprinted constructed bodily histories on a jury's consciousness, and, in a national arena, is used to amplify or deny the story an African American body appears to be telling.

The defense in the Simi Valley trial employed familiar language of black bestiality to construct Rodney King as a threat to the officers. The lawyers also slowed down the famous videotape so that it no longer existed in "real time" but rather in a slow dance of stylized movement that could be read either as self-defense or as threatening behavior. There was neither the sound of falling blows nor screams from King or from witnesses on the slowed-down tape. The movement existed frame by frame rather than in "real" time.[92] The rabidly conservative talk-show host Rush Limbaugh utilized the same technique on his television show, when he looped a snippet of the tape over and over and over again until it *did* look like Rodney King was advancing on the police officers, and there was no context for the movement. There is something compulsive—not to mention dishonest—about Limbaugh and Koon watching over and over and over again the same piece of film and using it to consolidate a self-justifying narrative of their own dominion.

Many black artists have invoked Rodney King's beating in different ways. Spike Lee opens *Malcolm X* with the videotape; Portia Cobb's own videotape replicates the beating with repeated tapping juxtaposed with young people of color discussing the case and police brutality;[93] Branford Marsalis's saxophone wails as many times as police batons landed on King's body. These artists, while responding to King's beating in different ways, all resisted the "documentary" form that dehistoricizes both the body and the event. Each of these artistic examples mitigates against a history of white-power narratives that have attempted to talk black people out of what their bodies know.

The artist Pat Ward Williams, while not responding to King, nonetheless calls into question the ways in which "documentary" photography has inadequately represented black life. She also questions the role of the photographer and his failure to *act* as witness. In *Accused/Blowtorch/Padlock*, she reinscribes an African American narrative onto a photograph of a man being lynched, which she found in *The Best of Life Magazine*.[94] Her narrative—which is handwritten, crammed within the frame, practically spilling over, in fact—begins with her sense of trouble, "Something is going on here," "I didn't see it right away," of wanting not to believe that the picture tells the story it does, not simply the overt story of a lynching but the far more troubling story of the complicity of the photographer, who watches but does not witness, who perpetuates, who is then in effect part of the lynch mob.

Williams invokes collective memory in three ways.

She says that "*Life* magazine published this picture," and then, "Who took this picture?" "*Life* answers—Page 141—no credit." *Life* magazine has become "life" itself, and the irony of a refusal to attribute agency or take responsibility for the crime committed. She says, "Could Hitler show pictures of the Holocaust to keep the Jews in line?" And then, with the line, "Can you be BLACK and look at this?" she forces her viewers to confront the idea of memory that would indelibly affect the way that someone sees what is before them. Williams's reframing of the picture—the slowing down of the narrative action and blowing up of individual parts, utilizes the same technique yet to different effect than the Court-TV or Rush Limbaugh reconstructions of the King video. The close-up of the image emphasizes the chains biting at the flesh, pulling the arms practically out of the socket, pulling against the chains away from the tree. She writes, "He doesn't look lynched yet. . . . WHO took this picture? Couldn't he just as easily let the man go? Did he take his camera and then come back with a blowtorch?" Then the narrative breaks into anguished grammatical fragments reminiscent of those heard in the slave narratives. "Where do you torture someone? BURN off an ear? Melt an eye? A screaming mouth? How can this photograph exist?"

Williams's final question is "Somebody do something," a call to action, which, if the implicit call of the King video, was seen in Los Angeles following the verdict. Both Williams and the lawyers for the L.A. police officers felt the need, for drastically different reasons, to overlay and articulate their version of the collective narrative on the public text. Williams's work asks the questions: What do

a people do with their history of horror? What does it mean to bear witness in the act of watching a retelling? What does it mean to carry cultural memory on the flesh? She provides one model for how to work with images we would rather forget, but which, in the remembering, shape our collective sense of who we are.

5. "POST-BLACK"? POST-SCRIPT

Three different black men told me these three true stories:

"When I was in Hawaii during the Second World War, the prostitutes who would go with the brothers would ask us could they see it, could they please see our tails. They meant *tails*."

"In Chicago I sat down on the bus, this would be a few weeks ago, and a white woman next to me whispered, so seriously, 'Does it hurt?' And I said, 'Does what hurt,' and she said, 'Your tail. Does it hurt to sit on your tail?'"

"In Philly they used to keep the primates in an area called 'Monkey Island.' One day there was a breakout. A keeper left the cages unlocked and the monkeys and apes and orangutans and chimpanzees escaped and roamed the nearby neighborhood. That night, there was a rash of phone calls to the local police from white people who lived near the zoo reporting black people staring in their windows, trying to break in."

I put these monkey stories here to invite us to think about the challenges and complex negotiations of black self-representation TODAY, and what it means to make black art out of and beyond such realities and zones of knowledge. Understanding the violence that has in large

part characterized our history and underscored our vulner-
ability actually opens an avenue to get to what is articulate,
resistant, and powerful in our tradition. Saying "I live
in this body," remaining embodied, is the first step to
transcending the limited and contorted expectations of
those bodies and finding the rampant power that is our
bequest. So "black" is always a metaphor, and "black" is
always real.

This essay has lived through some noteworthy changes
in African American cultural studies. "Essentialism" has
come under fire; to be "essentialist," even "strategically
essentialist," to use Gayatri Chakravorty Spivak's term, is
to be hopelessly unsophisticated and behind the times,
beyond the explicative powers of theory. It is worth
emphasizing that my use here of the term "collective
memory" is metaphorical. Metaphor observes in terms
that are often more vivid and therefore in some ways
more comprehensive than direct narration. Metaphor
fills in where logic cannot. Metaphor literally "transfers,"
which gives us another way to think about what is di-
rectly in front of us. In my metaphorical conception of
"collective memory" my colleague Paul Gilroy sees a veer
to a dangerous kind of myopic nationalism,[95] which is
plainly not my aim or ideology. I am thinking instead
of how this particular metaphor can help explain the
persistent and positively consolidating (non-nationalistic)
aspects of collective identification.

The 1990s in academia birthed a tricky trend: to so
theorize and construct and deconstruct identity "catego-
ries" that some were apt to forget women and people of
color themselves, in bodies, who wrote things that we

urgently needed to read and who remained grossly under-represented among the professoriat, women and people of color whose voices and actions in historical, political, and cultural life, were too often marginalized, trivialized, forgotten, or erased. As "race" became a "category," and much intellectual energy was put into critiquing "essentialism," the focus was lost on actual people of color, their voices and contributions, as well as, more practically, the importance of increasing their—our—empowered presence on campuses and in other workplaces. The extreme reaches are not unimaginable: a gender studies without women, "race" studies without black people and other people of color; as though the political struggles of those very people who make those classes and books and programs and departments exist were no longer relevant, as though we were now on a level playing field. I think of Gwendolyn Brooks's characteristically pithy words in the poem "I am A Black":

> According to my Teachers,
> I am now an African-American.
>
> They call me out of my name.
>
> BLACK is an open umbrella.
> I am Black and A Black forever.
>
> I am one of The Blacks. . . .
>
> I am other than Hyphenation.[96]

Brooks also felt the term "black" connected African Americans to other African diaspora peoples around the world. She enjoyed what she saw as its lack of pretense as well as its directness. Black power, black magic, black beauty, black love, and the million-dollar question is: How can a self-aware contemporary usage of BLACK reach beyond nostalgia and neo-romanticism?

In Kerry James Marshall's paintings, his figures are black-black: a black that is deep, potent, and alive in its density. It calls attention to itself and its usage; it is aware and ironic (of course nobody is that black, as nobody is, as the odious right sometimes reminds us, a "person of no-color"). Marshall writes about his struggle to get the color right, "to [have] that blackness breathe. . . . Extreme blackness plus grace equals power." Marshall's black figures become, then, full of light and *visible,* iconic and resonant, a new black that goes beyond both stereotype and romance to poetics.

Thelma Golden, always a trend-spotter and -setter when it comes to African American art, spun the phrase "post-black" into orbit in her essay in the catalogue for her 2001 Studio Museum in Harlem show of emerging black artists, "Freestyle." She attributes its coinage to conversations with her friend the artist Glenn Ligon. Post-black

> [is] characterized by artists who were adamant
> about not being labeled as "black" artists, though
> their work was steeped, in fact deeply interested,
> in redefining complex notions of blackness. In
> the beginning, there were only a few marked

instances of such an outlook, but at the end of the
1990s, it seemed that post-black had fully entered
into the art world's consciousness. Post-black
was the new black.[97]

Although Golden places the term's coinage in the con-
text of her and Ligon's "shared love of absurd uses of lan-
guage," the phrase caught fire and became an oft-quoted
descriptor of art that was "post-identity," and therefore
"post-multicultural," which at its far reaches was some-
times taken to mean, "post-black" in the sense of, oh, fi-
nally these black people have stopped complaining, come
'round to universal humanism, and given up on obsolete
demands like affirmative action. Welcome, once again, to
the mythical level playing field.

I am grateful for language that helps me think about
and name my own complexity and possibility as a black
person who makes art, and for the theories that think
us out of the straitjacketed constraints of racial ideolo-
gies imposed from the mythic within. We know these
in-group constraints can have distorting and damaging
effects. But as my grandmother might have said, let's not
be cute. In the early 1990s it was Rodney King, and the
unsung "Rodney Kings" who reminded us we might not
be as "post-" as we wish to be. There is no escaping our
bodies, even if we—or as we—transcend the limitations
and drawbacks of racialized thinking.

In my own case, as I began to come of age I have felt
the profound unease of misfitting the narrow descrip-
tors of "blackness" from the mainstream as well as (more
confoundingly) from black communities. What, besides

certain phenotypical characteristics, and certain progenitors, made me black? Why was racial identification and solidarity important if we were supposed to be "post-Civil Rights" and in the process of "overcoming"? How did my own embodied experiences as a black woman in a certain era and geography shape my sense of the possibilities as well as the limitations of blackness, and help me understand myself collectively? How did the exploration of self in society in my own work take me to deeper articulations of racial possibilities? In the study of black culture I found a bounty of rich, contradictory, disturbing, but ultimately sustaining responses to those questions. I found a way to interrogate and understand my own interior. Once called and now committed to that motherlode, I continue to struggle with its edifying conundrums.

NOTES

1. Zora Neale Hurston, "Characteristics of Negro Expression," in *The Norton Anthology of African American Literature,* eds. Henry Louis Gates Jr. and Nellie Y. McKay (New York: W.W. Norton, 1997), 1022.

2. Ntozake Shange, in *Moon-Marked and Touched by the Sun: Plays by African American Women,* ed. Sydne Mahone (New York: Theater Communications Group, 1994), 323.

3. See Adele Logan Alexander's comprehensive discussion of these issues, "'She's No Lady, She's a Nigger': Abuses, Stereotypes, and Realities from the Middle Passage to Capitol (and Anita) Hill," in *Race, Gender, and Power in America: The Legacy of the Hill-Thomas Hearings,* eds. Anita Faye Hill and Emma Coleman Jordan (New York: Oxford University Press, 1995), 3–25.

4. Gwendolyn Brooks, *To Disembark* (Chicago: Third World Press, 1981), 27.

5. Valerie Cassel, "Who Will Speak for Us? A Utopian Romance Novelette," in *Black Romantic: The Figurative Impulse in Contemporary African American Art* (New York: The Studio Museum in Harlem, 2002), 24.

6. Benjamin Brawley, *The Negro Genius: A New Appraisal of the Achievement of the American Negro in Literature and the Fine Arts* (New York: Dodd and Mead, 1937), 15.

7. Gwendolyn Brooks, *Blacks* (Chicago: Third World Press, 1987), 42.

8. *Ibid.*, 39.

9. Langston Hughes, ed., *Poems from Black Africa* (Blooming-
ton: Indiana University Press, 1963), 11.

10. All letters are quoted from the James Weldon Johnson
(JWJ) Collection, Langston Hughes Papers, with permission
of the Beinecke Memorial Library at Yale University. LH Cor-
respondence with SNCC, 1965, Box 1-8, JWJ Collection.

11. Aldon Nielsen's excellent work on *New Negro Poets U.S.A.*
argues that the anthology "established a continuity between
metrical formalism and the radical formalisms of projective
verse and the Black Arts." See Aldon Lynn Nielsen, *Black
Chant: Languages of African-American Postmodernism* (Cam-
bridge & New York: Cambridge University Press, 1997), 45.

12. Alan C. Golding, "A History of American Poetry Antholo-
gies," in *Canons,* ed. Robert Von Hallberg (Chicago: University
of Chicago Press, 1984), 279–307.

13. James Weldon Johnson, Preface from *The Book of American
Negro Poetry* in Gates Jr. and McKay, eds., *op. cit.,* 861.

14. Rosey E. Pool, ed., *Beyond the Blues: New Poems by American
Negroes* (Lympne Kent, England: The Hand and Flower Press,
1962), 31.

15. Walter Lowenfels, ed., *Poets of Today: A New American An-
thology* (New York: International Publishers, 1965).

16. Langston Hughes, *New Negro Poets* (Bloomington: Indiana
University Press, 1964), 57.

17. Arnold Rampersad, *The Life of Langston Hughes,* Vol. II
(New York: Oxford University Press, 1988), 375.

18. James C. Hall's wonderful book, *Mercy, Mercy Me: African
American Culture and the American Sixties* (New York: Oxford
University Press, 2001) offers a much more detailed account

and analysis of the skirmishes at that conference. He points out that the poet Melvin Tolson was ironically the one who criticized Hayden most sharply—ironic because Tolson was Hayden's age peer (rather than a member of a younger, presumably more rebellious generation) and was then, and is still, considered by many to be an esoteric poet whose work does not speak directly to timely "black" concerns.

19. Gates Jr. and McKay, eds., *op. cit.*, 1498.

20. Robert Hayden, " 'How It Strikes a Contemporary': Reflections on Poetry and the Role of the Poet," in his *Collected Prose* (Ann Arbor: University of Michigan Press, 1984), 9.

21. Gwendolyn Brooks, *Report from Page One* (Detroit: Broadside Press, 1972), 86.

22. Gwendolyn Brooks, "Annie Allen," in *Annie Allen* (New York: Harper & Brothers, 1949).

23. Gates Jr. and McKay, eds., *op. cit.*, 1271.

24. *Ibid.*, 1501.

25. Gwendolyn Brooks, *A Street in Bronzeville* (New York: Harper & Brothers, 1945), 2.

26. Gwendolyn Brooks, *In the Mecca* (New York: Harper & Row, 1968), 12.

27. Robert Hayden, *Words in the Mourning Time* (New York: October Press, 1971), 40.

28. Brooks, *Annie Allen, op. cit.*, 60.

29. Clarence Major, ed., *The New Black Poetry* (New York: International Publishers, 1969), 16.

30. Michael S. Harper, *Songlines in Michaeltree: New and Collected Poems* (Urbana and Chicago: University of Illinois Press, 2000).

31. Kimberly W. Benston, *Baraka: The Renegade and the Mask* (New Haven and London: Yale University Press, 1976), 42–43.

32. Larry Neal, "The Black Arts Movement," in Gates Jr. and McKay, eds., *op. cit.*, 1960.

33. The poet Quincy Troupe, characterizing his own stance in those years vis à vis the Black Arts Movement, said, "I love black people, but I'm not a black nationalist." Conversation with the poet, May 2003.

34. Nikki Giovanni, "The True Import of Present Dialogue: Black vs. Negro," in *The Black Poets,* ed. Dudley Randall (New York: Bantam Books, 1971), 318.

35. Sonia Sanchez, "personal letter no. 2," in *Homecoming* (Detroit: Broadside Press, 1969), 32.

36. Ishmael Reed, "black power poem," in *Conjure* (Amherst, Massachusetts: University of Massachusetts Press, 1972), 19.

37. Kimberly W. Benston, in *Afro-American Literary Study in the '90s,* eds. Houston A. Baker and Patricia Redmond (Chicago: University of Chicago Press, 1989), 164–185.

38. Michael C. Cooke, *Afro-American Literature in the Twentieth Century: The Achievement of Intimacy* (New Haven: Yale University Press, 1984).

39. Mary Helen Washington, "Introduction" in Anna Julia Cooper, *A Voice from the South* (New York: Oxford University Press, 1988 [1892]). All citations are from this edition.

40. See Leona C. Gabel, *From Slavery to the Sorbonne and Beyond: The Life and Writing of Anna Cooper* (Northampton, Massachusetts: Department of History of Smith College, 1982). The span 1886–1892 is Gabel's estimation of the time in which the essays in *A Voice* were written; I have not been able to verify precisely when each was composed and for which occasions. It

is important to note that several of these essays were first given as speeches and that Cooper continued to present them orally throughout the 1890s.

41. See Paula Giddings, *When and Where I Enter: The Impact of Black Women on Race and Sex in America* (New York: Bantam, 1984); Sharon Harley and Rosalyn Terborg-Penn, eds. *The Afro-American Woman: Struggles and Images* (Port Washington, New York: Kennikat, 1978); and Hazel Carby, *Reconstructing Womanhood: The Emergence of the Afro-American Woman Novelist* (New York: Oxford University Press, 1987) for detailed discussions of the African American women's intellectual climate in which Cooper wrote. For the writings of some of these women, see D.W. Culp, ed., *Twentieth Century Negro Literature: Or, a Cyclopedia of Thought on the Vital Topics Relating to the American Negro, by One Hundred of America's Greatest Negroes* (Atlanta, Georgia, Naperville, Illinois, and Toronto, Canada: J.L. Nichols & Co., 1902); Hallie Q. Brown, *Homespun Heroines and Other Women of Distinction* (New York: Oxford University Press, 1988 [1926]); Victoria Earle Matthews, "The Value of Race Literature," *Massachusetts Review* 27(2): 169–181, 1986 [1895]; and Mrs. N. F. Mosell, *The Work of the Afro-American Woman* (Freeport, New York: Books for Libraries Press, 1971 [1894]).

42. Patricia J. Williams, *The Alchemy of Race and Rights: Diary of a Law Professor* (Cambridge, Massachusetts: Harvard University Press, 1991), 6–8.

43. Louise Daniel Hutchinson, *Anna J. Cooper: A Voice from the South* (Washington, D.C.: Smithsonian Institution Press, 1981), 4.

44. Anna Julia Cooper Papers, Moorland-Springarn Research Center, Howard University, Washington, D.C.

45. Mary Helen Washington points out the ironic effect widowhood had on Cooper's career. Married women, African

American and white, were not allowed at that time to be teachers in Washington, D.C., and in much of the rest of the country. Thus, widowhood freed Cooper to pursue teaching, which would be her greatest life's work.

46. W.E.B. Du Bois, "The Talented Tenth," in *W.E.B. Du Bois: Writings* (New York: Library of America, 1986), 861.

47. Henry Louis Gates Jr., "The Hungry Icon: Langston Hughes Rides a Blue Note," in *Voice Literary Supplement* 76 (July 1989), 8.

48. Carolyn Heilbrun, *Writing a Woman's Life* (New York: Ballantine, 1988), 113–114.

49. Carby, *op. cit.*, 6.

50. Valerie Smith, *Self-Discovery and Authority in Afro-American Narrative* (Cambridge, Massachusetts: Harvard University Press, 1987), 19.

51. Scott Poulson-Bryant, "Dark and Lovely," in *Vibe*, Vol. 3, No. 7 (September 1995), 103.

52. Robert Farris Thompson, "Royalty, Heroism, and the Streets: The Art of Jean-Michel Basquiat," in *Jean-Michel Basquiat*, ed. Richard Marshall (New York: The Whitney Museum of American Art, 1992), 32.

53. Kevin Young, *To Repel Ghosts* (Cambridge, Massachusetts: Zoland Books, 2001).

54. See Thompson and Greg Tate in Marshall, ed., *op. cit.*; and bell hooks, "Altars of Sacrifice: Remembering Basquiat," in *Art in America* (June 1993), 68.

55. Thompson, *op. cit.*, 30.

56. Robert Storr, Introduction to *Jean-Michel Basquiat: Drawings*, ed. John Cheim (New York: Robert Miller Gallery, 1990).

57. Greg Tate, "Black Like B." in Marshall, ed., *op. cit.,* 56–57.

58. Jeanie Kasindorf, "Six Degrees of Impersonation," in *New York* (25 March 1991), 40–46.

59. *The Phil Donahue Show* transcript, 5 April 1991, 4.

60. Lawrence Otis Graham, "Invisible Man," in *New York* (17 August 1992), 28.

61. Lawrence Otis Graham, "Harlem on My Mind," in *New York* (27 September 1993).

62. Joyce Wadler, "His Story Is a Hit on Broadway, But This Con Man Is in Trouble Again," in *People* (18 March 1991), 99–100.

63. Arthur Jafa, "Discussion," in *Black Popular Culture,* a project by Michele Wallace, ed. Gina Dent (Seattle: Bay Press, 1992), 273.

64. The still most frequently used to advertise the film shows the two men grasping hands in an arm wrestle, eyes locked in an intense stare. To my eye, it echoes the black and white hand intertwined in the advertisement for Spike Lee's *Jungle Fever,* which calls up both erotic attraction and conflict.

65. "Denzel Washington Stars in Film *Ricochet,*" in *Jet* (Vol. 80, Issue 26, 14 October 1991), 57.

66. *Ibid.,* 58.

67. Richard Dyer, "Papillon," in *The Matter of Images: Essays on Representations* (London: Routledge, 1993), 126–127.

68. David Mills, "'Boyz' and the Breakthrough," in *The Washington Post* (21 July 1991), c1.

69. Marshall Frady, "The Children of Malcolm," in *The New Yorker* (12 October 1992), 78.

70. *Natural Health* (February/March 1993), 10.

71. I am grateful to Carol Breckenridge and Saidiya Hartman for helping me think about this term.

72. I say "bodies" with an understanding informed by and indebted to Hortense Spiller's provocative meditation on "body" and "flesh": "But I would make a distinction in this case between 'body' and 'flesh' and impose that distinction as the central one between captive and liberated subject-positions. In that sense, before the 'body' there is the 'flesh,' that zero degree of social conceptualization that does not escape concealment under the brush of discourse, or the reflexes of iconography. Even though the European hegemonies stole bodies—some of them female—out of West African communities in concert with the African 'middleman,' we regard this human and social irreparability as high crimes against the *flesh*, as the person of African females and African males registering the wounding. If we think of the 'flesh' as a primary narrative, then we mean its seared, divided, ripped-apartness, riveted to the ship's hole, fallen, or 'escaped' overboard." In Spiller's "Mama's Baby, Papa's Maybe: An American Grammar Book," in *diacritics*, Vol. 17, No. 2 (Summer 1987), 67.

73. Here Homi K. Bhabha's observations on "rumour" and "panic" are useful, even as he veers from my own conception of how transmission—"pass[ing] it on" takes place: "The indeterminacy of rumour constitutes its importance as a social discourse. Its intersubjective, communal adhesiveness lies in its enunciative aspect. Its performative power of circulation results in the contagious spreading, 'an almost uncontrollable impulse to pass it on to another person.' The iterative action of rumour, its *circulation* and *contagion*, links it with panic—as one of the affects of insurgency. Rumour and panic are, in moments of social crises, double sites of enunciation that weave their stories around the disjunctive 'present' or the 'not-there' of discourse. . . . The indeterminate circulation of meaning as

rumour or conspiracy, with its perverse, psychic affects of panic, constitutes the intersubjective realm of revolt and resistance." In Bhabha's *The Location of Culture* (London: Routledge, 1994), Chapter 10, 200.

74. "The 'Rodney King' Case: What the Jury Saw in *California v. Powell*," 1992. Courtroom Television Network. Courtroom language cited is from this videotape.

75. Frederick Douglass, *Narrative of the Life of Frederick Douglass, An American Slave* (1845), ed. Houston A. Baker Jr. (New York: Penguin Books, 1982).

76. Harriet A. Jacobs, *Incidents in the Life of a Slave Girl*, eds. L. Maria Child and Jean Fagan Yellin (Cambridge, Massachusetts: Harvard University Press, 1987 [1861]).

77. *The History of Mary Prince, a West Indian Slave. Related by Herself*, eds. Moira Ferguson and Ziggi Alexander (London: Pandora, 1987 [1831]).

78. Michael Slate, "Shockwaves: Report from L.A. Rebellion," in *Revolutionary Worker*, 1993.

79. Spillers, *op. cit.*, 67.

80. Audre Lorde, *Chosen Poems Old and New* (New York: W.W. Norton, 1982), 104.

81. Accounts of the fan's weight vary between 75 and 150 lbs.

82. *Jet*, Vol. 8, No. 19 (15 September 1955), 8.

83. James Baldwin astutely place the attention on Till's murder in context: "The *only* reason, after all, that we have heard of Emmett Till is that he happened to come whistling down the road—an obscure country road—at the very moment the road found itself most threatened: at the very beginning of the segregation-desegregation—not yet integration—crisis, under the knell of the Supreme Court's *all deliberate speed*, when

various "moderate" Southern governors were asking Black people to segregate themselves, *for the good of both races,* and when the President of the United States was, on this subject, so eloquently silent that one *knew* that, in his heart, he did not approve of a mongrelization of the races." James Baldwin, *The Evidence of Things Not Seen* (New York: Holt, Rinehart, and Winston, 1985), 40–41.

84. Anne Moody, *Coming of Age in Mississippi* (New York: The Dial Press, 1968), 103.

85. Charlayne Hunter-Gault, *In My Place* (New York: Farrar, Straus & Giroux, 1992), 115–116.

86. Shelby Steele, "On Being Black and Middle Class," in *Commentary* (January 1988), 43.

87. Muhammad Ali, *The Greatest* (New York: Random House, 1975), 34–35.

88. This is an anecdote that was told to me by a teacher at Dunbar High School in Chicago in April of 1993, but there are many, many such stories that circulate in black communities and discourse.

89. Eisa Davis, "Maison des Esclaves, Goree Island, Senegal." Unpublished poem, 1992.

90. Seth Mydans, "Their Lives Consumed, Officers Await Second Trial, in *The New York Times* (2 February 1993), A9.

91. Adrian Piper, *Pretend* (New York: John Weber Gallery, 1990).

92. Others have discussed the phenomenon. See especially Patricia J. Williams, "The Rules of the Game," in *Reading Rodney King,* ed. Robert Gooding-Williams (New York: Routledge, 1993), and Patricia Greenfield and Paul Kibbey, "Picture Imperfect," in *The New York Times* (1 April 1993), A15.

93. Portia Cobb, *No Justice, No Peace* (video), 1993.

94. Pat Ward Williams, *Accused/Blowtorch/Padlock,* 1986 (mixed media, photograph, silkscreen, 60" x 100") in *The Decade Show: Frameworks of Identity in the 1980s* (New York: Museum of Contemporary Hispanic Art, The New Museum of Contemporary Art, The Studio Museum in Harlem, 1990), Plate XC.

95. Paul Gilroy, *Against Race* (Cambridge, Massachusetts: Harvard University Press, 2000).

96. Gwendolyn Brooks, "I Am a Black," in *Children Coming Home* (Chicago: The David Company, 1991), 5.

97. Thelma Golden, "Introduction: Post . . . ," in *Freestyle* (New York: The Studio Museum in Harlem, 2001), 14.

ACKNOWLEDGMENTS

◆

This book is the product of many years' worth of thinking, reading, talking, and ruminating: it is therefore impossible to thank everyone whose shadow falls across these pages. But a few must be mentioned. First, innumerable thanks to my agent, the sage and splendid Faith Hampton Childs, who took me under her wing when my first poems appeared in the late 1980s and whose support of my work has never wavered. Thanks to my supporters at Graywolf Press, especially Fiona McCrae, Anne Czarniecki, J. Robbins, and Janna Rademacher, for providing such a hospitable home for my work. To Robert Stepto and Hazel Carby for helping envision and them making a place for me at Yale University, to Paul Gilroy for continuing to roll out the welcome mat in African American Studies, and to Geneva Melvin and Janet Giarratano who make the department run smoothly and help make my school life such a pleasure. To my smart, diligent students over the years who have seen some of these ideas begin to sprout on my syllabi and who have helped me with various tasks, a million thanks. Evans Richardson fact-checked the manuscript with great care. To the editors who have encouraged and published some

of this work in earlier form, especially Amy Cappellazzo, the first to invite me to write about the visual arts. To the Cave Canem Poetry Workshop for African American Poets, the imaginary audience made real. To the community of brilliant scholars whom I consider my "generation" and to whom I'm always talking when I write: Phillip Brian Harper, Lindon Barrett, Nicole King, Jennifer Devere Brody, Tricia Rose, Sharon Holland, Gina Dent, P. Gabrielle Forman, Amy Robinson, Paul Rogers, Saidiya Hartman, Farah Jasmine Griffin, Robin D.G. Kelley. What company to keep! Donna Franklin, Kellie Jones, and Emily Bernard have inspired and supported me as sister-scholars and nurturing friends. To my mother and father, Adele and Clifford Alexander, who have encouraged my endeavors over all these years, and particularly to the examples of my mother's own sterling scholarship and my father's way of telling it like it is. By birth and by marriage I am blessed with many brothers and sisters and nieces and nephews: I hope this book makes all of you proud. And finally, to my husband, Ficre, and my sons, Solomon and Simon, who lived with me through the making of this book with their own good humor, devotion, and starlight: thanks, guys, to you most of all.

Some of these essays were first published elsewhere in earlier versions:

"Meditations on 'Mecca': Gwendolyn Brooks and the Responsibilities of the Black Poet," in *By Herself: Women Reclaim Poetry,* ed. Molly McQuade, Graywolf Press, 2000.

"The World According to *Jet,* Or, Notes toward a Notion of Race-Pride," in *The Voice Literary Supplement,* March 1994.

"Anna Julia Cooper: Turn-of-the-Century 'Aframerican' Intellectual," in *Signs: A Journal of Women in Culture and Society* (Winter 1995, Vol. 20, No. 1).

"Denzel," in *Representing Black Men,* eds. Marcellus Blount and George P. Cunningham. London: Routledge, 1996.

"A Black Man Says 'Sorbet,'" in *Two Cents: Works on Paper by Jean-Michel Basquiat, Poetry by Kevin Young,* ed. Amy Cappellazzo, Miami-Dade Community College, 1995.

"'Can You Be BLACK and Look at This?': Reading the Rodney King Video(s)," in *Black Male,* ed. Thelma Golden, Whitney Museum, 1995, and *The Black Public Sphere,* ed. The Black Public Sphere Collective. Chicago & London: University of Chicago Press, 1995.

ELIZABETH ALEXANDER was born in New York City and raised in Washington, D.C. She is the author of four collections of poetry, *The Venus Hottentot, Body of Life, Antebellum Dream Book,* and *American Sublime,* which was a finalist for the 2005 Pulitzer Prize in Poetry. She is also the author of two collections of essays, *The Black Interior* and *Power and Possibility: Essays, Interviews, Reviews,* and a collection of poems for young adults, *Miss Crandall's School for Young Ladies and Little Misses of Color* (co-authored with Marilyn Nelson). She recently edited *The Essential Gwendolyn Brooks.* She has read her work across the United States and in Europe, the Caribbean, and South America, and her poetry, short stories, and critical prose have been published in numerous periodicals and anthologies. On January 20, 2009, Alexander delivered a poem at the inauguration of President Barack Obama. She is the recipient of the Alphonse Fletcher, Sr. Fellowship for work that "contributes to improving race relations in American society and furthers the broad social goals of the U.S.

Supreme Court's Brown v. Board of Education decision of 1954," and the 2007 Jackson Prize for Poetry, awarded by Poets and Writers. Alexander is a professor of African American Studies and American Studies at Yale University, and also teaches in the Cave Canem Poetry Workshop. She lives with her family in New Haven, Connecticut.

The Black Interior has been set in Adobe Caslon Pro, an open type version of a typeface originally designed by William Caslon sometime between 1720 and 1766. The Adobe version was drawn by Carol Twombly in 1989.

Book design by Wendy Holdman.
Typesetting by BookMobile Design and
 Publishing Services.
Manufactured by Friesens on acid-free paper.